The Campus History Series

SOUTHERN ILLINOIS
UNIVERSITY CARBONDALE

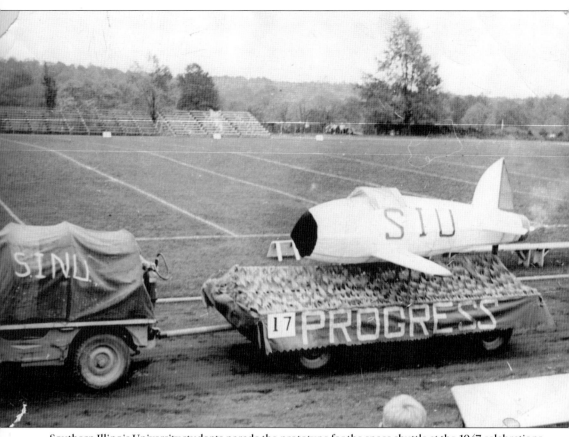

Southern Illinois University students parade the prototype for the space shuttle at the 1947 celebrations heralding the change from Southern Illinois Normal University to Southern Illinois University.

On the cover: Please see above. (Courtesy of Media and Communication Resources.)

The Campus History Series

SOUTHERN ILLINOIS UNIVERSITY CARBONDALE

THE HISTORY STUDENTS OF SIUC

ARCADIA
PUBLISHING

Published by Arcadia Publishing
Charleston SC, Chicago IL, Portsmouth NH, San Francisco CA

Printed in the United States of America

Library of Congress Catalog Card Number: 2006924399

For all general information contact Arcadia Publishing at:
Telephone 843-853-2070
Fax 843-853-0044
E-mail sales@arcadiapublishing.com
For customer service and orders:
Toll-Free 1-888-313-2665

Visit us on the Internet at http://www.arcadiapublishing.com

The following individuals contributed to this project:
Matthew Borowicz
William A. Griffiths
Mark Harper
Leatha Johnson
Jeffrey Julson
David Markwell
Karen Mylan
Daniel Stockdale
Michael Tow
Christopher Walls
James Whistle
Emily Williams
Neal Young

Editors:
Matthew Borowicz
William A. Griffiths
James Whistle
Michael Batinski

CONTENTS

ACKNOWLEDGMENTS

We would like to thank the following people for their patience, help, donations, contributions, and time: Lucia Amorelli, Russell Bailey, Phil Bankester, Ron Bath, June Kiehna DeBernardi, Big Muddy Media, Gordon Billingsley, Randy Bixby, Brad Brailsford, Linda Brandon, Ed Buerger, Tom Busch, Martin Cieslak, Carol Blackwell, Jerry Col, Sue Davis, Dorothy Dodson, Kristine Domaracki, Yesenia Espinoza, Jeff Garner, Gene Green, the Interfaith Center, Bill Ittner, Dede Ittner, Alfredo Jahn, David Koch, H. B. Koplowitz, Crystal Kuykendall, Ralph Kylloe, Cindy Larkin, Sue Liemer, John Lopinot, Gary Marx, John May, Tom Moulton, Pennie Moulton, Joan Henley (Myers), Marji Morgan, Phyllis O'Neill, Ted Orf, Guy Richter, Alex Robertson, Joe Robinette, Jan Roddy, Jill Schneider, Paul Schneider, Sigma Lambda Beta fraternity, Sigma Gamma Lambda sorority, Joanne Simpson, Judy Simpson, Shirley Clay Scott, SIUC Student Center Department of Student Activities, Buzz Spector, Lee Ellen Starkweather, Jay Stemm, Jack Stroehlein, Ken Trask, Tom Vaught, Elaine Wagner, Lois Watts, Jeff Wendt, Tom Wilfong, and Diane Worrell. We would not have been able to complete this project without your involvement.

INTRODUCTION

Remember those invigorating, warm October weekends with the leaves starting to turn and the first hints of frost in the morning air, perhaps a drive out to Giant City, or a walk around campus lake? Tom Moulton, class of 1962, and Pennie Moulton, class of 1963, chose such a weekend to drive up from Oklahoma to visit friends in the Carbondale area and to tour their alma mater. Soon after they read the announcement in *The Southern Alumni* that a group of history students was compiling a photograph history of student life at Southern Illinois University (SIUC) since the Second World War, they wrote promising that once they found their pictures they would deliver them. We met at the Longbranch Café on the north side of Carbondale's town square and spent the next hour talking about student life then and the changes since. In addition to their own pictures, they brought a copy of *Life* magazine from October 1960 that included a cluster of photographs depicting life on campus then. Pennie was in one picture, at the rear of a dormitory room peeking out at the camera.

Meeting the Moultons illustrates the wonderful experience of collecting these photographs and constructing this history. It was not the collecting alone that made this project so rewarding. There were those moments of discovery—that time when we opened an e-mail attachment and found a photograph of a homecoming or a cardboard boat race, or that morning when we received a collection by the mail. The experience was rewarding because we had so many first-hand encounters with former students who so eagerly and generously shared their memories, memorabilia, and pictures. Through such meetings with the Moultons and so many others, such as Franklin Hamilton and Dede and Bill Ittner, we learned what SIUC has meant to so many of its students.

This project began with two simple rules. This photograph history focused on the students—not buildings or teachers and administrators, but the students. It was about students, done by students, and for students. Second, the project would focus on the era from World War II to the present. In the course of a year, several graduate students participated in this project. Final responsibility for the individual chapters was distributed as follows: Leatha Johnson and Jeffrey Julson for chapter one, William A. Griffiths and Mark Harper for chapter two, Karen Mylan and James Whistle for chapter four, David Markwell for chapter five, and Matthew Borowicz and Neal Young for chapter six. Chapter three was a collective enterprise that helped each of the authors to gain perspective. The responsibility for final revisions and preparations of the manuscript was assumed by Matthew Borowicz, William A. Griffiths, and James Whistle.

One

THE BEST YEARS OF OUR LIVES, THE G. I. BILL TO *I LOVE LUCY*

Jeff Julson and Leatha Johnson

As World War II came to its end, the United States looked to the postwar era with both optimism and the wrenching memories of the Great Depression. The G. I. Bill was passed in 1944 to cope with the eventual flood of veterans back into civilian life. Following the dropping of the atomic bombs in August 1945 and the subsequent demobilization, veterans flocked to the nation's universities. At Southern Illinois Normal University (the "Normal" was removed in 1947), the student population nearly doubled between the spring and fall of 1946. This growth led to the vast enlargement of the campus over the next three decades.

Between 1945 and 1954, the civil rights movement gained momentum across the nation, culminating with the landmark Brown versus the Board of Education decision in 1954. The protest at Carter's Café in 1946 and Dick Gregory's time on the track team were two glimpses of this movement at the campus. International students, especially from Formosa, Taiwan, added to SIUC's diverse student body. By 1950, some political diversity was not accepted as professors were forced to take loyalty oaths to the United States due to Cold War fears and the rise of McCarthyism.

Students watched movies like *The Best Years of Our Lives*, *A Letter from Three Wives*, *All About Eve*, and *Singin' in the Rain* at either the Varsity Theatre or the A-La-By Drive-in. Television gradually replaced radio over these 10 years, as shows such as *Father Knows Best* and *I Love Lucy* became hits. And the baby boom was born. Other forms of entertainment included the student union or simply "hanging out" with friends or family. With this brief background, here is a sampling of what was happening on campus.

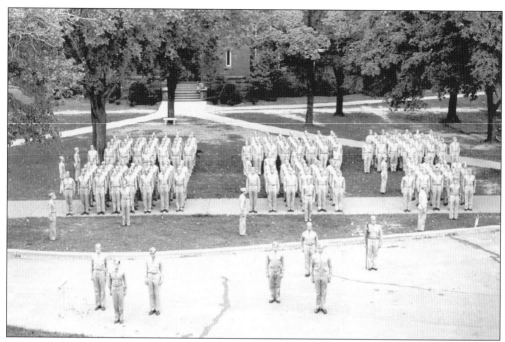

During World War II, Southern Illinois Normal University served as a training facility for the military. The barracks built for these individuals would become campus fixtures for the next 50 years. (Courtesy of Righter)

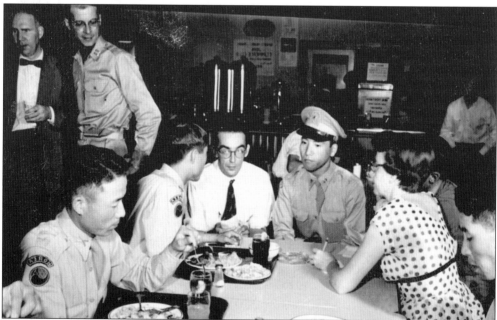

During the Korean War, many World War II veterans were recalled to active duty. They were stationed in stateside bases as replacements for regular soldiers heading overseas. The ROTC program remained strong during this decade as well. In October 1954, 168 Korean officers on their way to Fort Benning, Georgia, for training stopped in Carbondale because Fort Benning did not have room for them yet. These Korean officers toured SIUC and were interviewed by *The Egyptian*.

Returning veterans added a new dynamic to the campus experience. Additional housing, faculty, classrooms, and various other facilities had to be constructed in a timely manner. Adult married students with children became a common sight on campus. The barracks built for the military during World War II were converted to family housing in the years after the war, as this picture shows.

This was the recreation hall at Southern Acres, which was a collection of buildings cleaned up and painted by veterans and their families. These buildings were located at the ordnance factory at Crab Orchard Lake. The university leased enough space for 104 two-bedroom apartments for married veterans, as well as space for 300 single veterans. Out of a total student population of 1,443 in March 1947, there were 648 veterans. In January 1948, there were 1,304 veterans on campus, out of 2,703 students.

The baby boomers made their mark on campus life, and they earned that title. Kindergarten at Southern Acres was run cooperatively by the wives who were housed there. Day cares and recreation centers sprang up, often out of the labor and time of the veterans and their families.

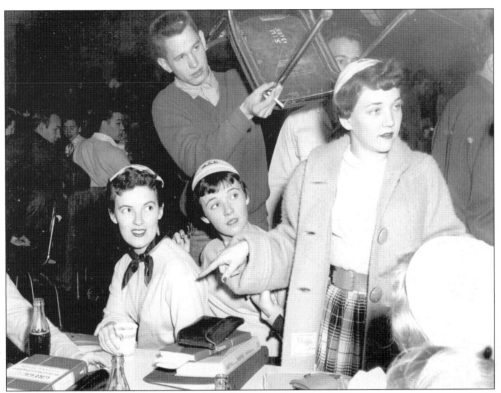

With enrollment projected at over 5,500 for the fall of 1955, the campus was growing quite quickly in the decade after World War II. These students negotiate some of the cramped conditions on campus, with a little bit of patience and laughter.

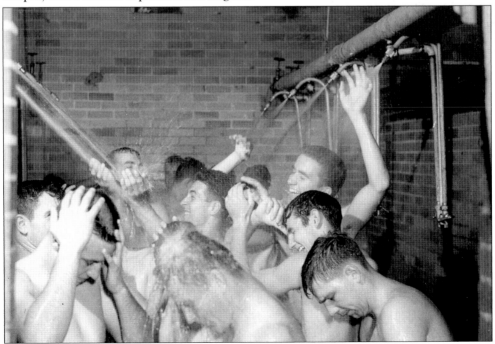

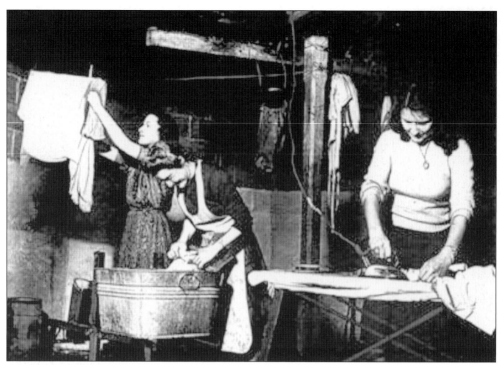

The decade after World War II was also a time for a return to normalcy. Despite crowded conditions, everyday chores were performed with ingenuity and efficiency. SIUC also saw an influx of female students, and *The Egyptian* published articles geared toward women, urging them to "loosen up" and enter the dating scene rather than studying at night, while other headlines touted "Home Economics Girls Live in Luxury While Earning University Credit."

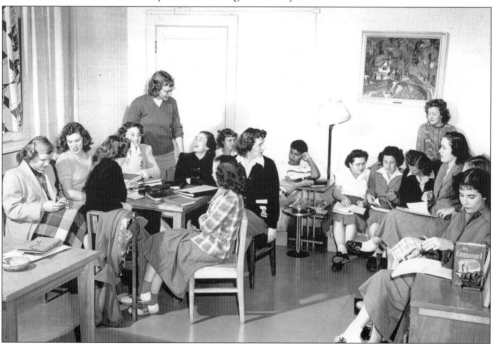

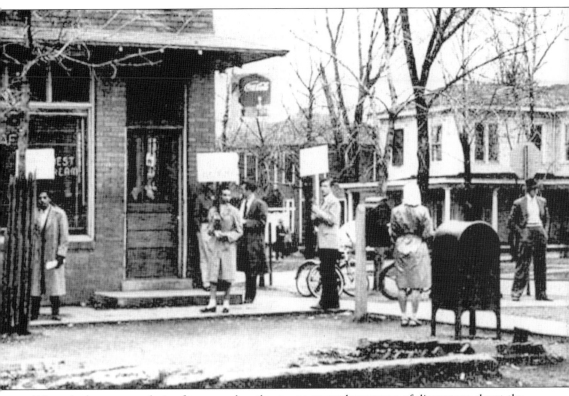

Although there was a desire for normalcy, there was an undercurrent of discontent about the position and treatment of African Americans in the United States. In 1947, Carter's Café, an establishment just off campus, was picketed by black and white students as it was a segregated diner. This was a part of the growing civil rights movement in Southern Illinois. In 1925, African Americans student founded the Dunbar Society in order to create a support network and provide entertainment opportunities. Jenny Jones, a student at the university around 1940, recalled that "we would go to the movie theater downtown (the Varsity Theatre), but we would have to sit upstairs in the balcony behind the railing." By the early 1950s, white students also showed support for the cause of desegregation by joining their classmates in the Varsity Theatre's balcony.

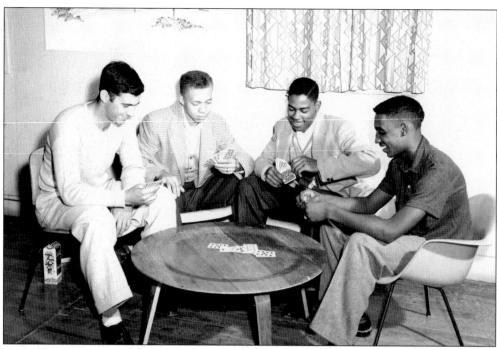

There were many types of entertainment available on campus between 1945 and 1954. One could play cards with a group of friends. By the mid-1950s, the student union, located in Wheeler Hall, had billiards; tables for chess, checkers, and pinochle; record players; television; and other forms of entertainment for students to choose from. There was also a ditto machine (10¢ for sheets) and a typewriter for 12¢ an hour or five minutes for a penny.

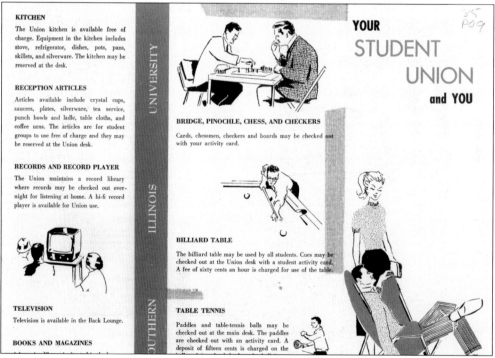

KITCHEN
The Union kitchen is available free of charge. Equipment in the kitchen includes stove, refrigerator, dishes, pots, pans, skillets, and silverware. The kitchen may be reserved at the desk.

RECEPTION ARTICLES
Articles available include crystal cups, saucers, plates, silverware, tea service, punch bowls and ladle, table cloths, and coffee urns. The articles are for student groups to use free of charge and they may be reserved at the Union desk.

RECORDS AND RECORD PLAYER
The Union maintains a record library where records may be checked out overnight for listening at home. A hi-fi record player is available for Union use.

TELEVISION
Television is available in the Back Lounge.

BOOKS AND MAGAZINES

BRIDGE, PINOCHLE, CHESS, AND CHECKERS
Cards, chessmen, checkers and boards may be checked out with your activity card.

BILLIARD TABLE
The billiard table may be used by all students. Cues may be checked out at the Union desk with a student activity card. A fee of sixty cents an hour is charged for use of the table.

TABLE TENNIS
Paddles and table-tennis balls may be checked out at the main desk. The paddles are checked out with an activity card. A deposit of fifteen cents is charged on the

YOUR
STUDENT
UNION
and YOU

SOUTHERN ILLINOIS UNIVERSITY

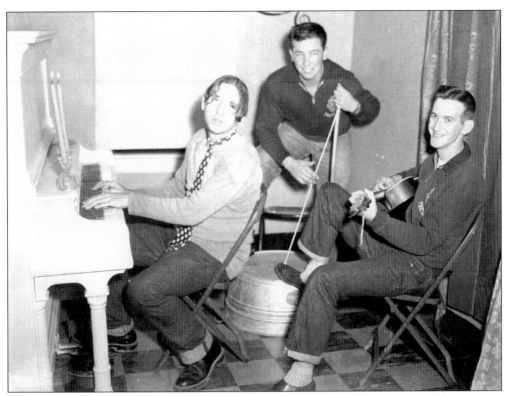

Entertainment could also be found elsewhere on campus. Jerry Lee Lewis would come to prominence in 1957 with songs such as "Great Balls of Fire." In these pictures taken in 1954, the student playing the piano appears to be part of the early wave of such music.

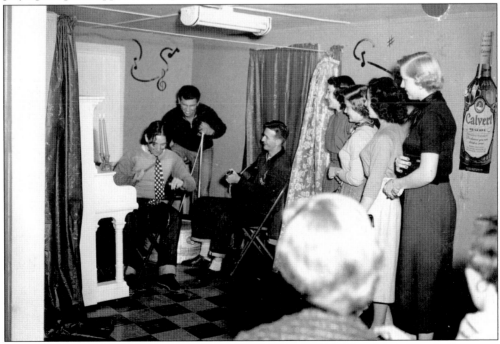

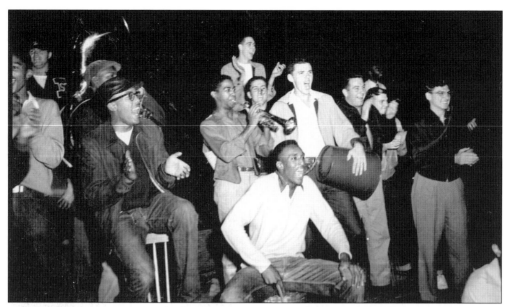

Impromptu jam sessions and performing arts have always been a part of SIUC student life, as shown in these two pictures. In addition to student performers, the university drew artists such as Duke Ellington, who performed here on March 24, 1950. Other popular artists of the period included Rosemary Clooney, Nat King Cole, Dean Martin, and Hank Williams.

Formal dances were a part of student entertainment. Shown here, June Kiehna and Joseph Bernardi pose for a picture at the ROTC Ball in 1953. Kiehna made her gown in a home economics advanced dressmaking class.

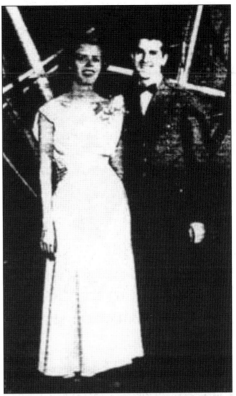

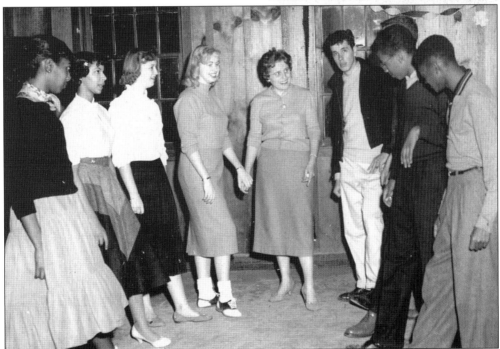

Dances could also be much more informal, as students simply gathered at one person's place for the evening. Are they dancing to "The Hokey Pokey?"

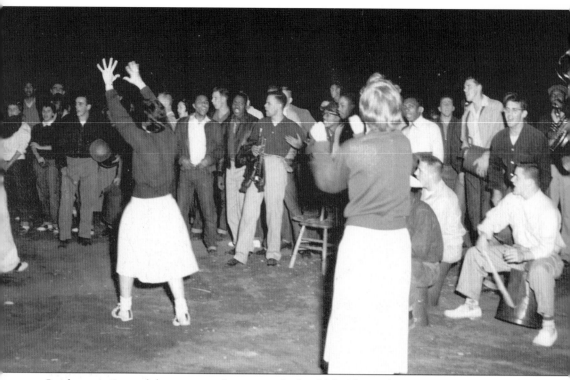

Outdoor parties and dances were also a part of school life. This gathering occurred in the fall of 1954 in the week before homecoming.

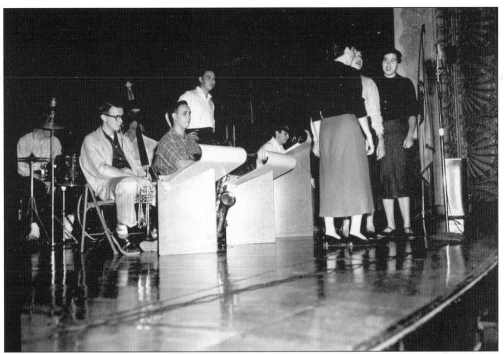

Student-led performances formed another part of student life on campus. This musical performance in 1954 was held in Shryock Auditorium, a 1,200-seat auditorium that was constructed in 1917. Doesn't the audience look enthusiastic?

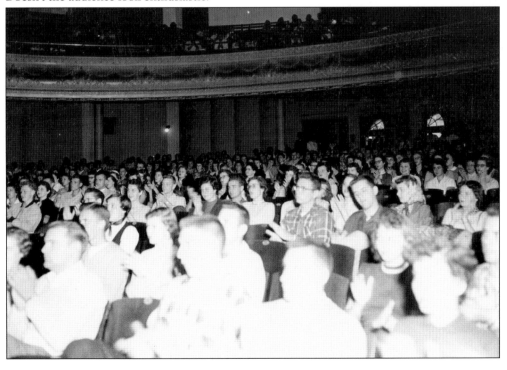

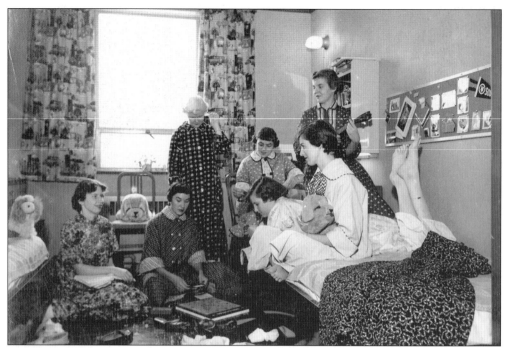

This was a dormitory room in Woody Hall, which was the women's dormitory on campus. Students, especially female students, were strictly regulated through the student conduct code. There would be many protests against the student conduct code in the 1960s.

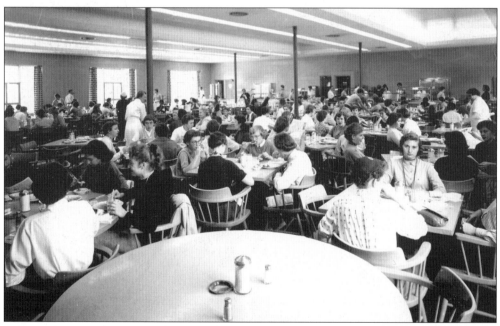

SIUC's cafeteria is shown in 1954. Protests by students over the cost of meals and the quality of service from 1945 to 1947 led to a number of changes in how the cafeteria was run.

This is the life! Winter exam week was never like this, as Jay Ellis can testify. The West Frankfort student studies for summer school tests at Crab Orchard Lake, which is near Carbondale, on August 12, 1954.

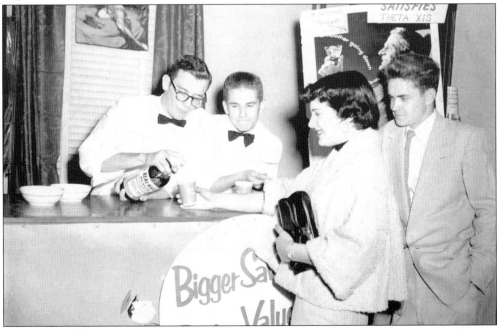

At a pledge party thrown by the Theta Xis in 1954, two soda jerks made sure that people's glasses were kept filled. The poster on the right had a sign that read "A Satisfied Pledge," while a racy poster resided on the wall behind the soda jerks.

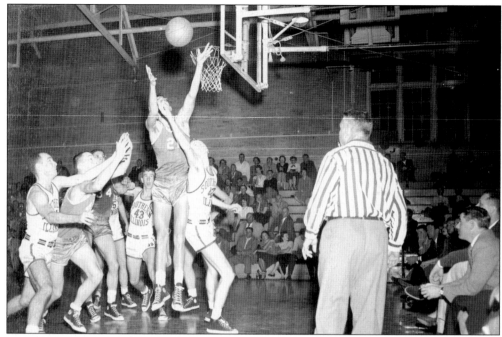

Sports were another campus diversion. Basketball was a popular sport for spectators, topped only by football in the fall.

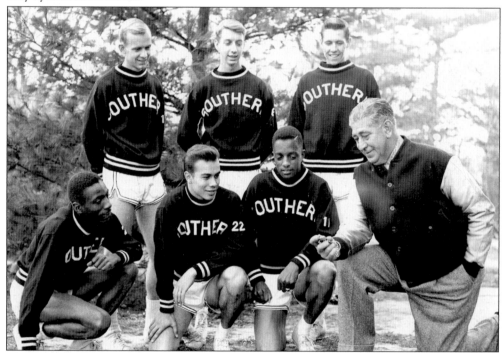

Dick Gregory (first row, on the left) was a track star during his time at SIUC. Because he was African American, Gregory had to have special permission to enter Kentucky in order to run in a track meet there. When he came back to Carbondale to celebrate his wins, many bars on the strip refused to serve him.

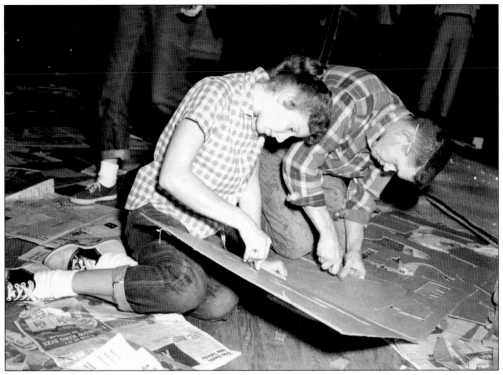

In 1954, SIUC played Michigan Normal University in the homecoming game. The students above are working on making floats for the homecoming parade. The float for Woody Hall, the women's dormitory, is pictured below. The words around the arch are "Heaven Help Michigan."

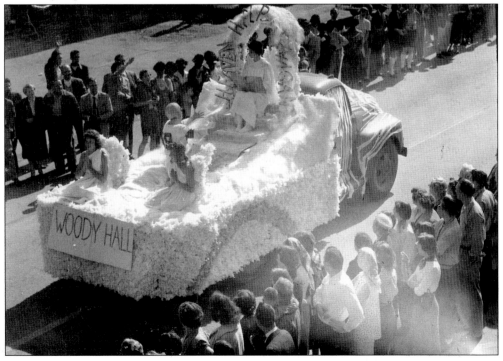

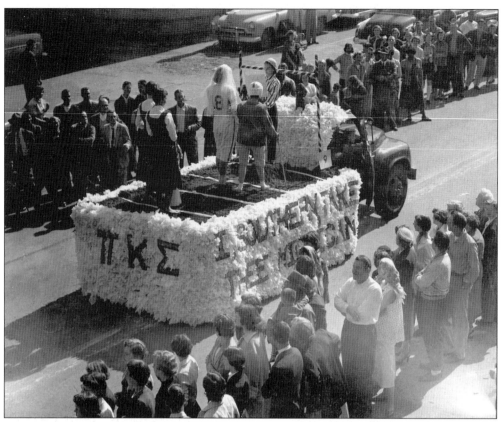

The crowd watches as the float for the Phi Kappa Sigma fraternity rolls through Carbondale. With a theme of a wedding on a football field, the writing on the side is "I Southern Take Thee Michigan."

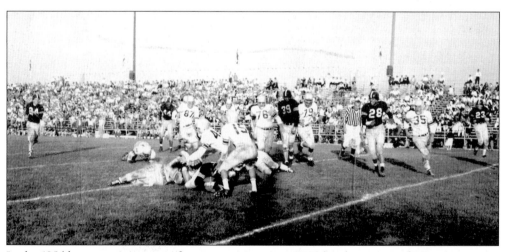

In the 1954 homecoming game, after a promising start, SIUC lost by a score of 20 to 0.

The 1954 homecoming dance at SIUC had an Ancient Egyptian theme, which played on the fact that Southern Illinois is known as "Little Egypt."

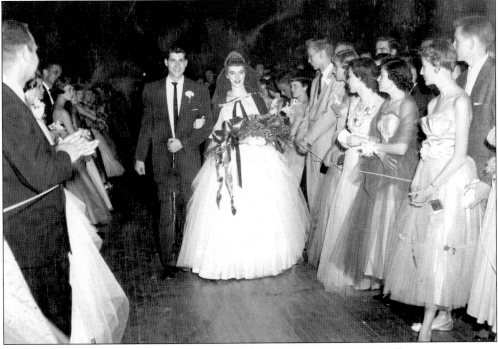

This is the 1954 homecoming queen, Ann Travelstead, on her way to the ball.

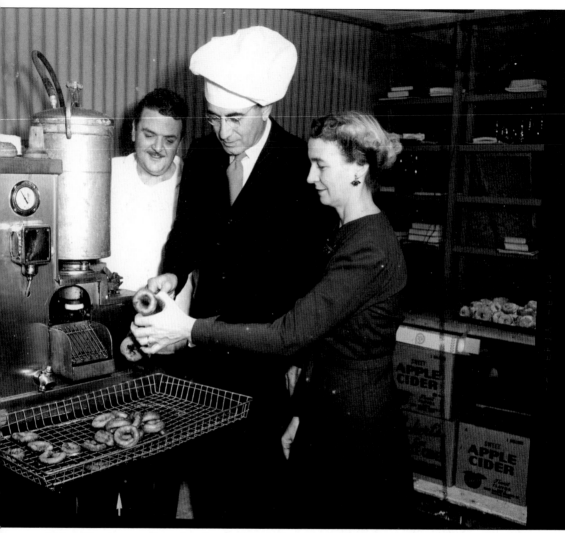

Delyte Morris was selected as the president of Southern Illinois University in 1948. He led SIUC during a period of tremendous growth that strained the campus as many new students swarmed into higher education.

Two

HOME IS A TENT ON LITTLE GRASSY LAKE

William A. Griffiths and Mark Harper

College life during the 1950s and 1960s brought McDonald's fast food. Little Bill's sold six hamburgers for $1, and Piper's Parkway Restaurant sold "KC Steak with fries, a salad bowl, bread and butter, and all the tea or coffee you could drink" for $1.75 in 1959!

Television became America's favorite pastime. One may have seen *The Magnificent Seven* at the Varsity Theatre in November 1960, and Marilyn Monroe and Yves Montand in *Let's Make Love* the same week. The choice also included Bridget Bardot in the slightly more risqué *School for Love* at Marlowe's Drive-in in Herrin. McAndrew Stadium also operated as an outdoor movie theater and boasted a new 20-foot screen in 1956.

John F. Kennedy and his opponent, then Vice President Richard Nixon came to McAndrew Stadium in October and November 1960 to canvass for presidential votes. Both saw crowds of over 10,000. Nixon had been there previously, in 1956, where he recalled speaking in "a large gymnasium," Shryock Auditorium.

There was great change within the university, the core curriculum changed from that of a normal school to more of what it is today, offering classes in the arts, sciences, and philosophy. Three hundred of the 1957 freshman male intake was housed in tents on Little Grassy Lake, due to the lack of available student housing. Delyte Morris ensured that investments were made in new buildings for classrooms, student living accommodations, and technological advancement. In fact, it appeared that "Southern has left the conventional system of higher education a hundred years behind." Morris's budget for 1957 was an amazing $62 million, a figure the university cannot get close to achieving today.

November 1957 saw a clinical service center to serve the disabled, paid for by a grant from the U.S. Office of Rehabilitation ($36,905). This was followed soon after by the building of Thompson Point, the first floor of which was planned specifically for these needs.

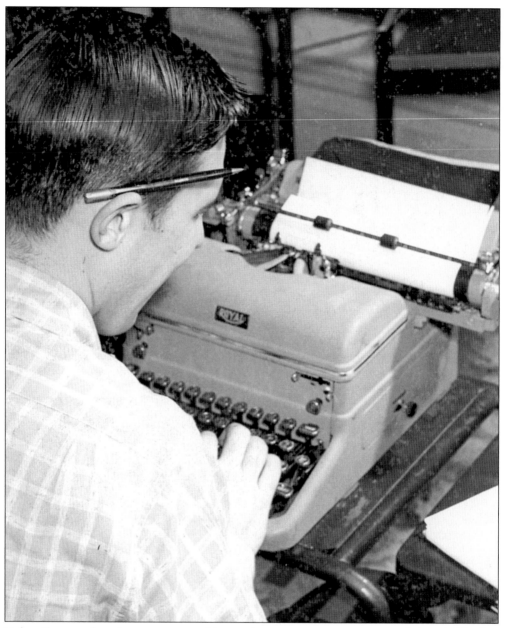

Before the use of modern computers, this was the way papers were presented. A veritable slew of businesses surrounded the campus renting out these machines. (Courtesy of Cole.)

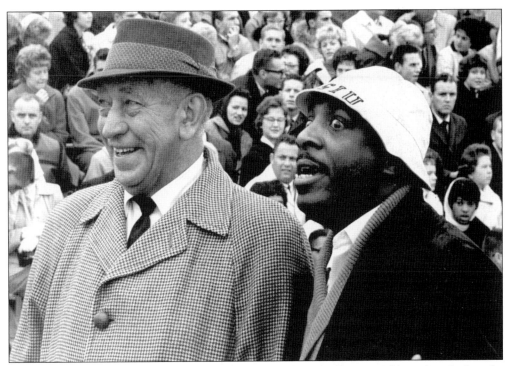

Leland "Doc" Lingle and Dick Gregory are in this photograph taken in 1964, not long before the sad death of Doc. (Courtesy of Dede Ittner.)

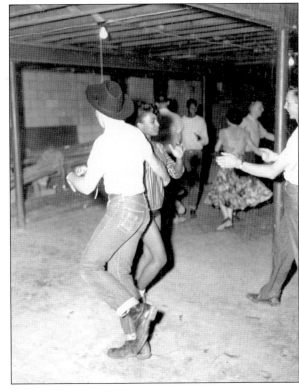

The interfaith center on Illinois Avenue held multi-racial and cultural events like this barn dance in the mid-1950s. (Courtesy of the Interfaith Center.)

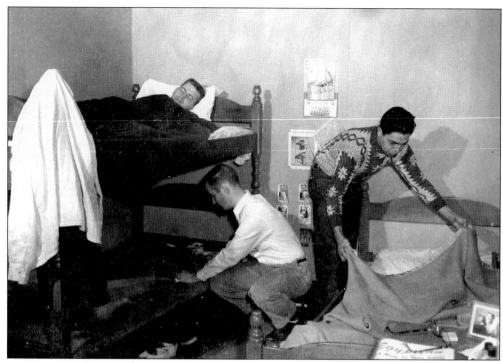

Students are shown enjoying the comfort of bachelor housing. (Courtesy of Media and Communication Resources.)

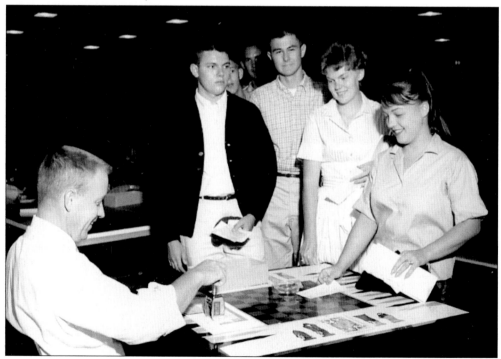

New students line up for their identification documents during new student week in 1962. (Courtesy of Media and Communication Resources.)

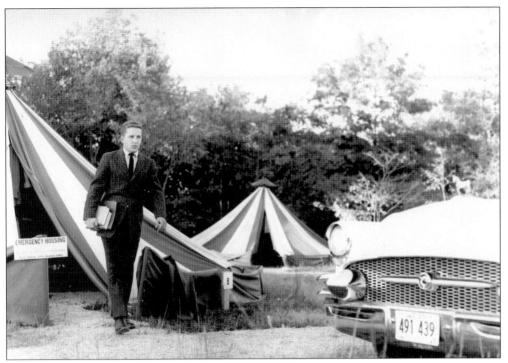

The "housing" is shown at little Grassy Lake in August 1957. Note how this student is able to make himself so presentable that it seems almost posed. (Courtesy of Media and Communications Resources.)

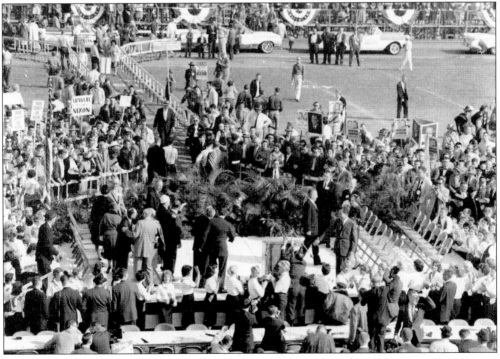

Richard Nixon prepares to speak at McAndrew Stadium in 1960. (Courtesy of Media and Communications Resources.)

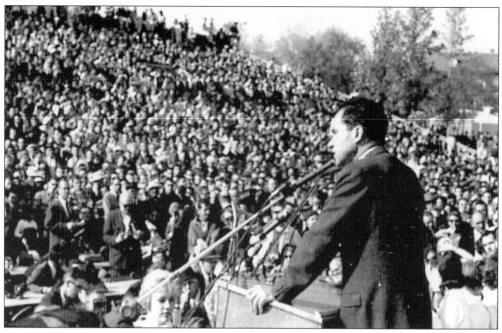

Nixon speaks to the crowd of more than 10,000 at McAndrew Stadium. Some three weeks later, John F. Kennedy addressed a similar size crowd immediately before the presidential election. (Courtesy of Media and Communications Resources.)

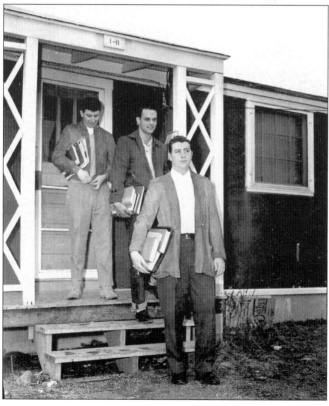

Three bachelors pose outside their remodeled war-time hut. (Courtesy of Media and Communications Resources.)

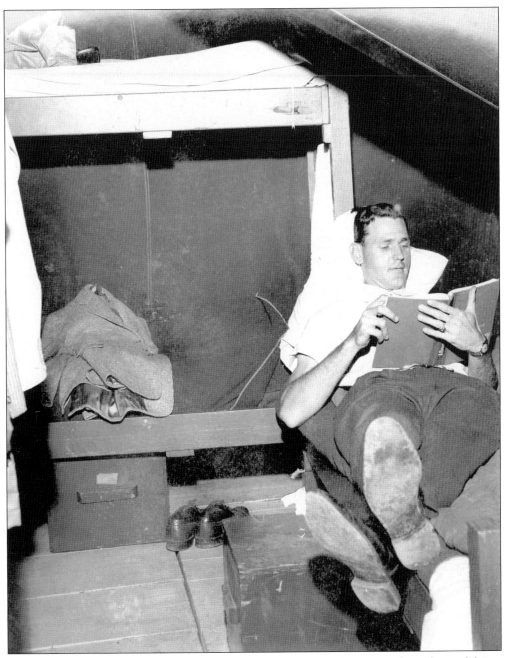

Shown here is the inside of those tents at Little Grassy Lake, but this time without the model. Just how comfortable can one person get?

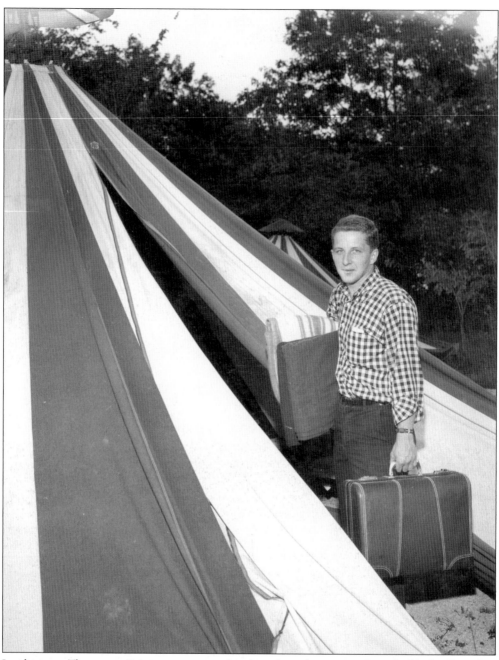

Just because Thompson Point was not completed on time, the new students had little choice but to buckle down and make the best of it. This must be a picture of day one because no one could look that smart after a few days!

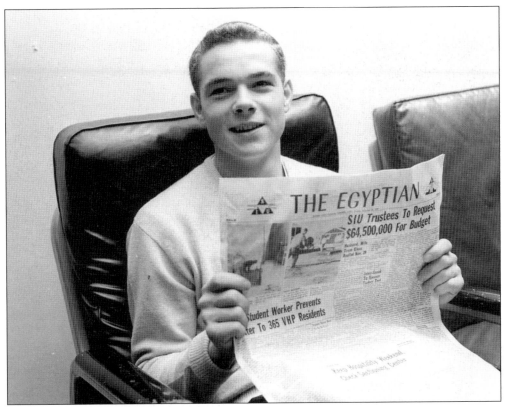

This students lounges around reading *The Egyptian*. A closer look reveals that in 1956 SIUC was requesting over $64 million from the state.

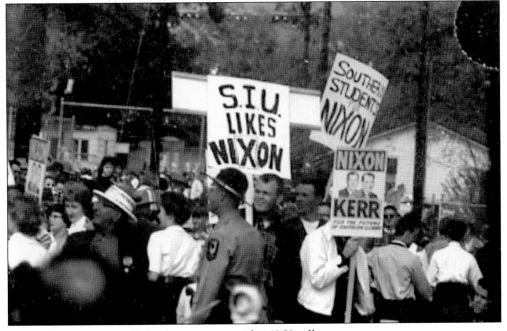

Shown here are some of Nixon's supporters at his 1960 rally.

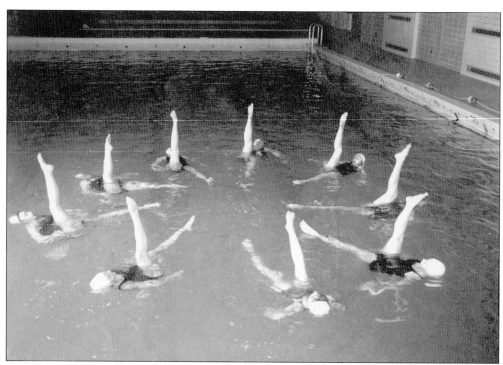

Long before it was an Olympic sport, SIUC boasted a synchronized swimming team, the Aquaettes, seen here practicing at a local school pool.

Some of the old World War II huts are seen here set up as married housing. Presumably the old "felted" walls shown here were, at least, sided before any bad weather set in. The authors wonder just how warm they were in the winter. (Courtesy of Media and Communications Resources.)

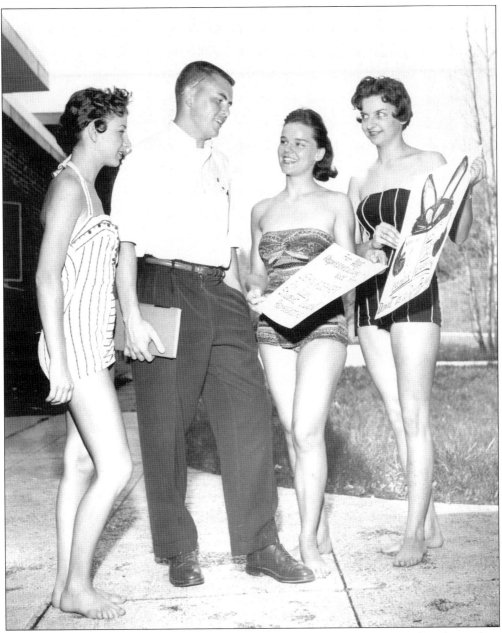

"Dick Baldwin is accosted near Woody Hall by three lovelies with campaign ideas for student elections." Two of the beauties were Annette Stilley and Jean Foehrer. (Courtesy of Media and Communications Resources.)

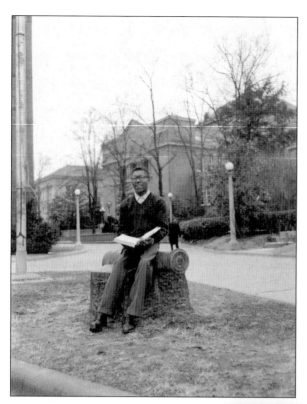

A shot of the cannon in 1957. The cannon was a landmark outside Shyrock Auditorium for many years. It disappeared some years ago, but has recently been found covered in several layers of paint. (Courtesy of Media and Communications Resources.)

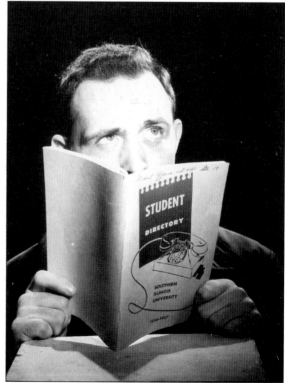

In the days before cell phones and iPods, students kept in touch by the old hardwired telephones. Here a student muses over who he will call. (Courtesy of Media and Communications Resources.)

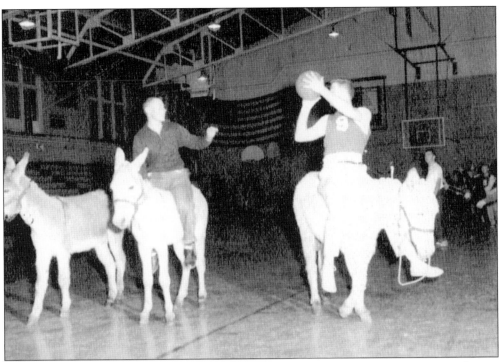

Donkey basketball is played in Davies Gymnasium in 1956. It is not known who won, or who was responsible for "dung patrol." (Courtesy of Media and Communications Resources.)

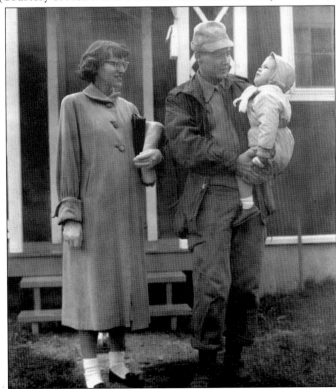

Mr. and Mrs. Ed Charles, with their son David, are being evacuated on November 17, 1956, from the Chautauqua housing project following the discovery of liquefied gas in the line serving apartment heating and cooking facilities. (Courtesy of Media and Communications Resources.)

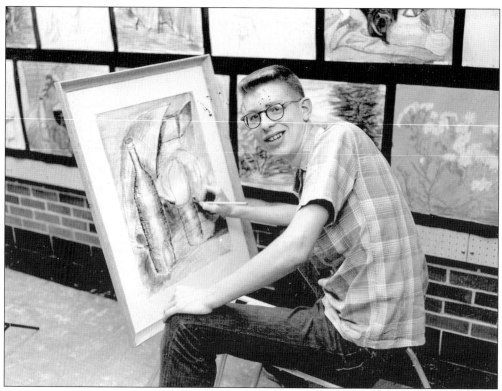

This man's haircut illustrates a genuine 1957 "flat-top."

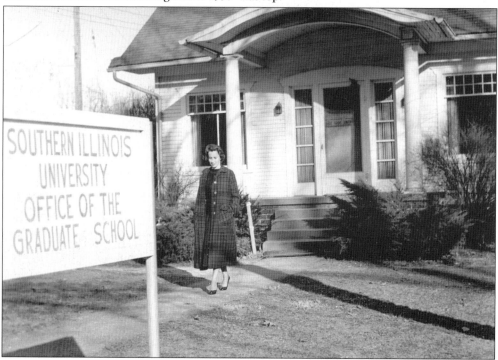

Shown here is a more peaceful and efficient graduate school office.

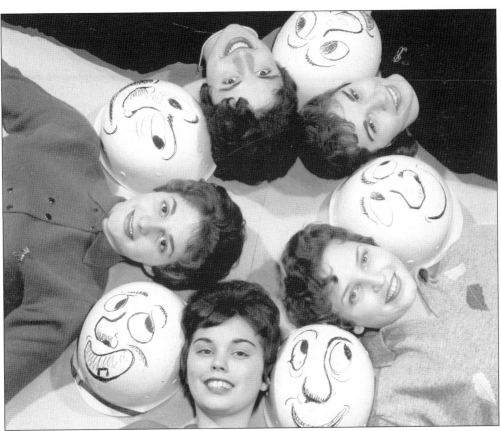

Five girls and six cans of hair spray create 1960s style. (Courtesy of Media and Communications Resources.)

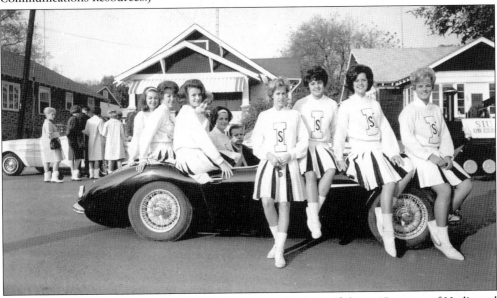

During homecoming in 1964, a group of girls pose with a beautiful car. (Courtesy of Media and Communications Resources.)

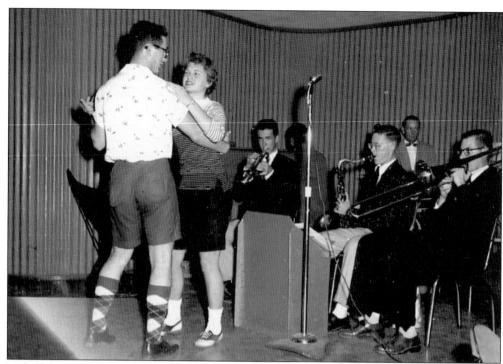

Homecoming 1956 obviously included a tasteful socks competition, along with the usual festivities. (Courtesy of Media and Communications Resources.)

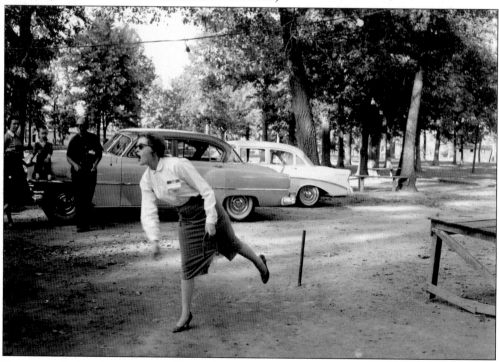

One young lady enjoys a game of horseshoes at an SIUC function in 1956. (Courtesy of Media and Communications Resources.)

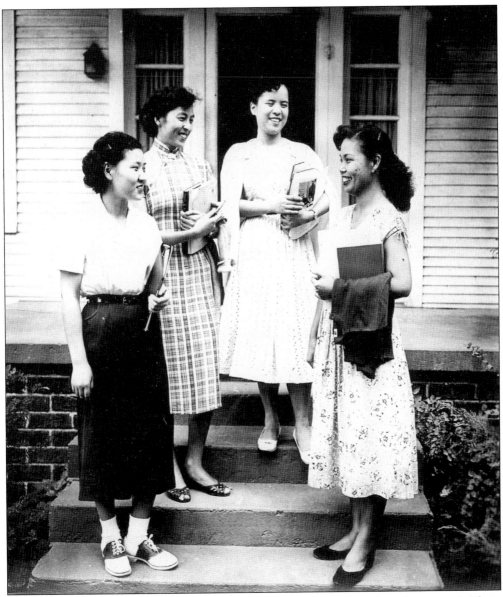

Showing the cultural diversity of the university, these international students, maybe from Formosa, Taiwan, are on the steps of their American home in 1956. (Courtesy of Media and Communications Resources.)

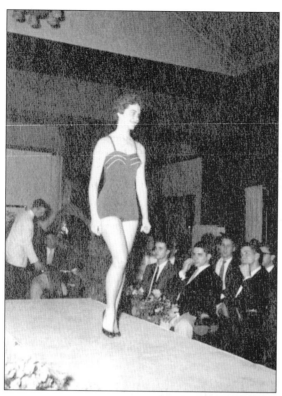

Shown here is the Miss SIUC
competition in 1956. (Courtesy of Media
and Communications Resources.)

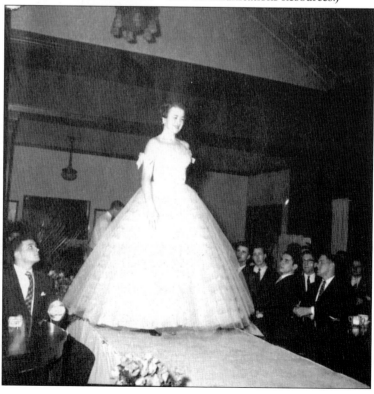

Morris Library, taken in 1956 (on the left), is almost unrecognizable as the library currently undertaking major remodeling in 2006. (Courtesy of Media and Communications Resources.)

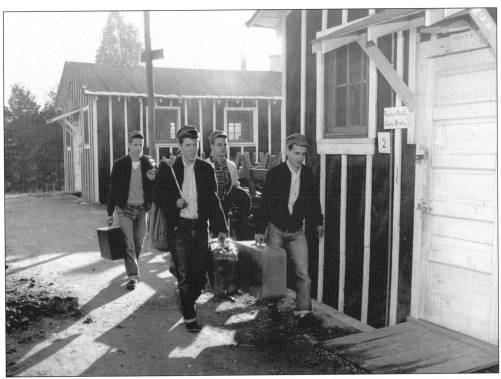

Students are shown moving into the "new" housing in 1955. (Courtesy of Media and Communications Resources.)

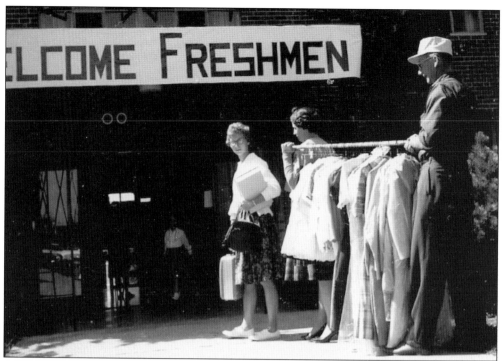

Students moved into a slightly more modern university in 1963. (Courtesy of Media and Communications Resources.)

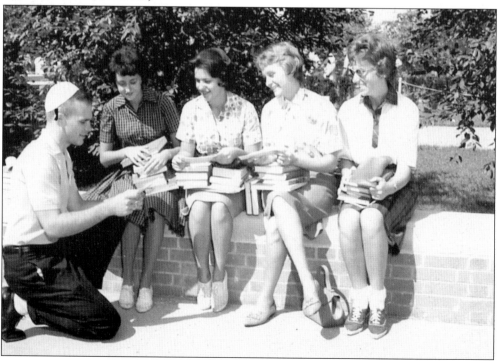

Note the beanie and the bobbie sox at new students week in 1962. (Courtesy of Media and Communications Resources)

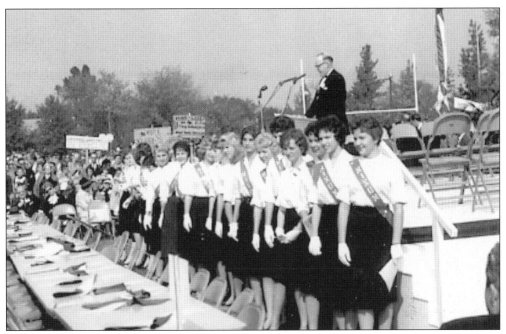

The "Nixon Girls" line up before his visit to McAndrew Stadium in 1960. (Courtesy of Media and Communications Resources.)

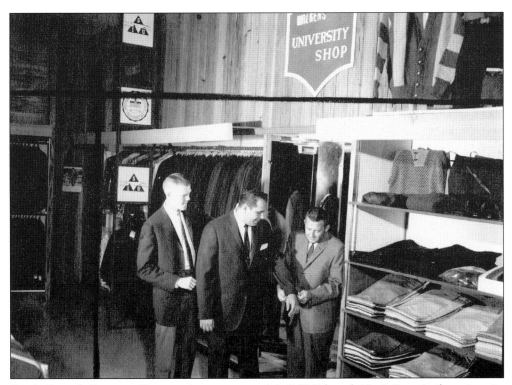

Football coach Carmone Piccone tries on a new suit in J. W. Edwards Men's Store in the university shop. (Courtesy of Media and Communications Resources.)

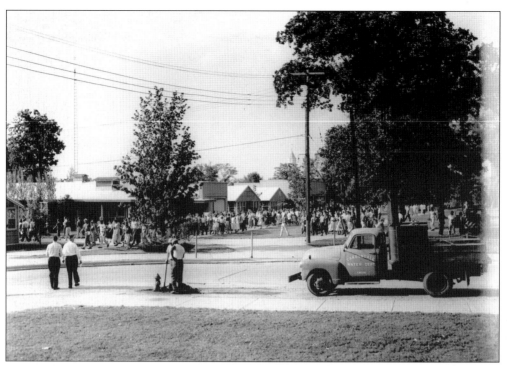

This is a busy view looking toward Pulliam Hall in 1957. (Courtesy of Media and Communications Resources.)

Southern Acres men's housing residents pose for the camera in 1963. Is this where the "party school" nomenclature comes from? (Courtesy of Media and Communications Resources.)

The SIUC Student Council is shown in 1957. From left to right are (kneeling) Danny Telford, Zelma Johnson, and William Berry; (standing) Myrna Kuhn, Thomas Piper, Yvonne Anton, Mary Ann Edwards, Gary Heape, Daniel Bode, and Carol Van Dover. (Courtesy of Media and Communications Resources.)

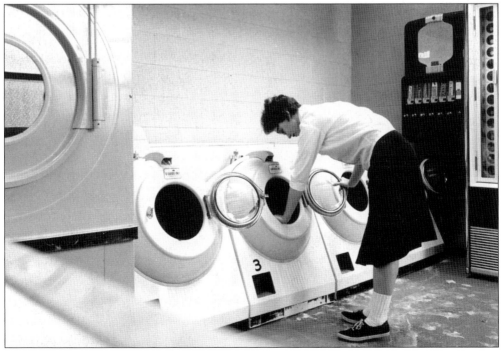

It must be wash day, or is this a dryer, in what looks like a brand new launderette in 1959. (Courtesy of Media and Communications Resources.)

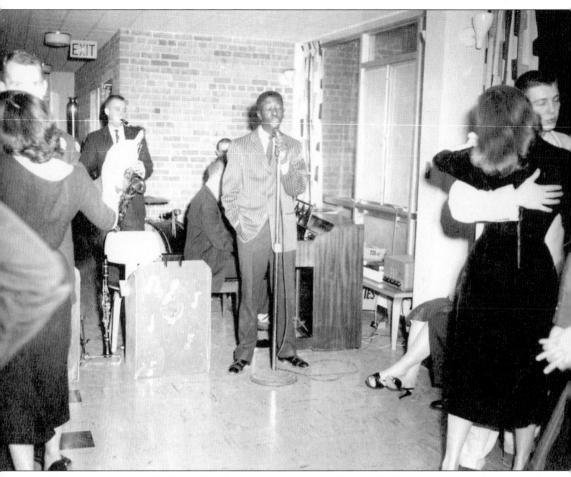

A formal dance is held in the ladies dormitory at Woody Hall in 1957. The crooner is, unfortunately, unidentified. (Courtesy of Media and Communications Resources.)

Three

THE TIMES
THEY ARE A-CHANGIN'

Michael C. Batinski and the group

In September, when the quarter started, cars jammed Illinois Avenue, with Pennsylvania and New York license plates as common as those from Illinois. The student body was changing in size and identity. When classes met, one listened to the accents from Chicago—Skokie, Rogers Park, and the South Side—mingle with those from Southern Illinois. Why did they come? It was cheap, said a student from Rhode Island—$126 a month at Brookside Manor and even less expensive out of town. It was also exciting. They came to study with Buckminster Fuller and his associates. One could see the geodesic domes sprout up around the campus. There was the cardboard boat regatta. While Dustin Hoffman was advised in *The Graduate* that "plastics" was the future, this seemed to be the place to find alternatives.

Times were a-changin', so Bob Dylan reminded everyone. Students thought so. Conventions were questioned. Dormitory hours fell. Coeducational dormitories opened. Jane Fonda came to campus. Chistine Jorgenson, a pioneer recipient of a sex-change operation, spoke to students. The *Daily Egyptian* speculated that it might be okay for a woman to smoke a pipe. The women's center opened off campus. Birth control material was made available on campus. The word sexism was in the air; some charged campus authorities with being sexists.

SIUC was witness to the nation's remarkable transformations. African American students who had desegregated Little Rock High had come to Carbondale. The Varsity Theatre had been desegregated. Don Boydston, director of athletics, had been driving through the South with his wife Jo Ann to recruit African American athletes. And they were coming.

Students gathered before university president Delyte Morris's home to demand the establishment of a Black American Studies program; they gathered before Morris Library to protest the war in Vietnam. The draft and student deferments seemed to be in everyone's mind. Had you kept your 2S status (draft exemption status for students)? Some were serving and some dying. Veterans returning from the war were speaking out against America's involvement. In the wake of the Cambodian invasion and the killings at Kent State and Jackson State, the campus debate spilled into the streets.

The memories of the politics linger with sounds and places: the weekends at the spillway, an afternoon at the Dairy Queen, gathering to hear Coal Kitchen, buying Cat Stevens's "Catch Bull at Four" for $3.57.

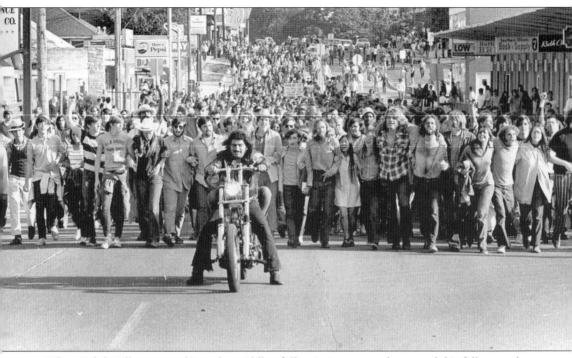

When Ralph Kylloe stepped into the middle of Illinois Avenue to photograph his fellow students marching in protest against the Vietnam War with "Anteater" in the lead, he captured what is a central image of the decade. Kylloe has since moved on to run an antique store in Lake George, New York. Anteater is still around. But this photograph that later appeared in H. B. Koplowitz's *Carbondale After Dark* is a centerpiece in memories of the times.

Kylloe's photograph must be balanced with other images of student life. Not all students were protestors then, just as many in this so-called apathetic time are as actively engaged as their parents were in the 1960s. The traditions of earlier times persisted. Saluki fans celebrated the basketball team's victory at the National Invitational Tournament in 1967. Autumn homecoming remained an important event.

With change, differences became pronounced, and contrasts jostled side by side against each other. Styles reflected differences regarding gender.

Hair styles marked the changes as well. And on the strip one would find even deeper challenges to convention. Mike "Freedom Man" Belchak summoned us to stop pursuing the dollar and to make his point walked the street with a dollar bill suspended before him by a coat hanger attached to his hat. On another day he was in a large cardboard box with signs of protest: "Walking is Nicer and Fun" and "Let's All Work for Free."

56

Joan Baez, folk music, Bob Dylan, the change in hair style and dress set the tone.

Dustin Hoffman rescued his love from the terror of conventional wedding in *The Graduate*. And wedding traditions bent with the times.

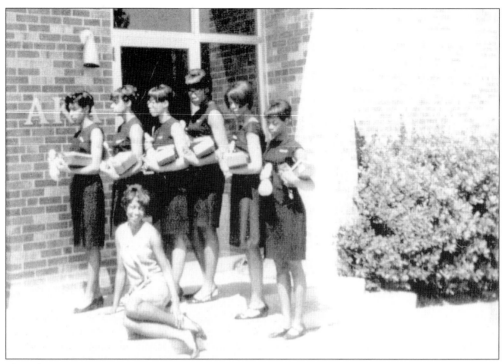

The African American student body reflected the shifts and varieties with convention reflected in the sorority system on campus.

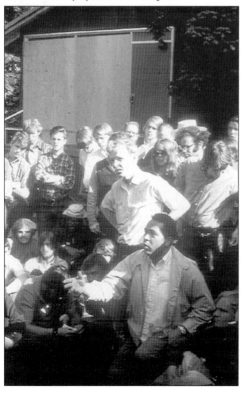

Others actively engaged in student activism. The Black Panthers also organized on campus and in town.

Memories turn on the gathering places such as Giant City and Devils Kitchen, where students gathered with the dogs and frisbees.

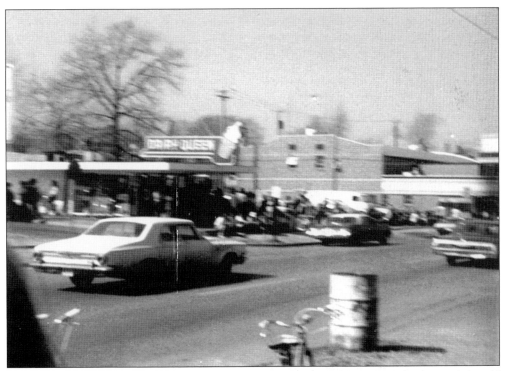

In town they gathered at the Dairy Queen and stretched out on the lawn in front of the old Holden Hospital.

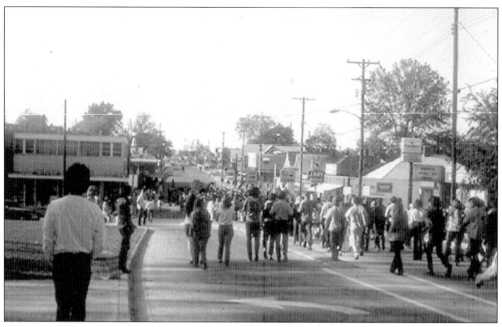

Yet Ralph Kylloe's photograph captured the tensions brewing. Students protested dormitory hours and the principle of in loco parentis. There was the war in Vietnam and the symbols of the military—ROTC and the Vietnam Studies Center. Students gathered before the old Baptist Student Center and next to President Morris's home (where Faner Hall now stands) to demand the creation of a Black American Studies program.

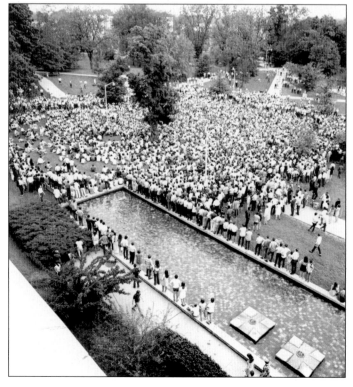

And the protestors gathered on campus, often before Morris Library.

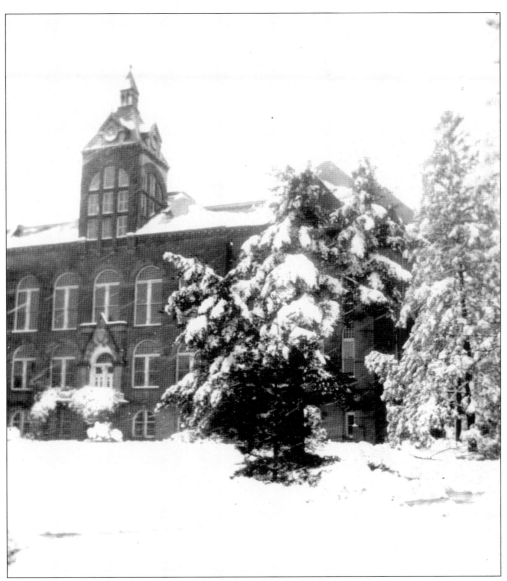

Old Main, standing at the core of the old campus, served as a reminder of a quieter past. Franklin Hamilton, a student at the end of World War II, took this photograph in 1945 and kept it as reminder of his days on campus.

One Sunday morning in May 1969, Old Main caught fire. Fire companies from as far as Mount Vernon came to put out the blaze, but it was all in vain. Students volunteered to help stop the fire. But within hours the building had been utterly destroyed.

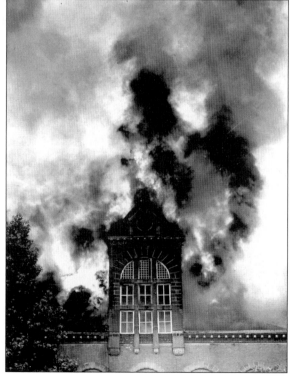

Some believed the fire was set deliberately. The story persists. When Faner Hall was being built, stories circulated that the building was designed to be riot proof. That story is not true; the building had been designed before the student protests had begun. But both stories—right or wrong—linger in local lore as reminders of the times.

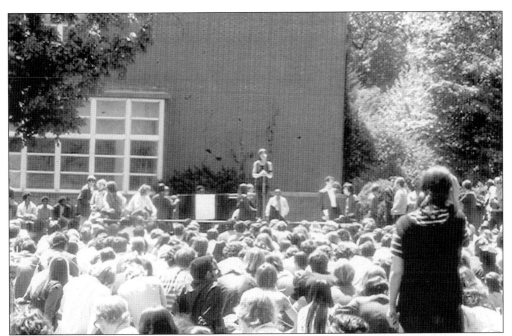

In the fall of 1969, students gathered for Moratorium Day to register their discontents about the war in Vietnam. They concluded with a reading of the names of students serving in the war and singing softly "We Shall Overcome."

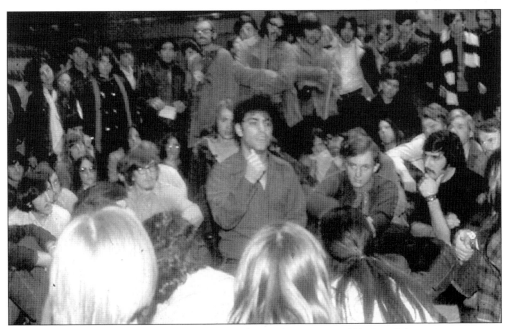

In early 1970, Abbie Hoffman, founder of the Yippie Movement and leader of the antiwar protests at the Democratic Convention in Chicago in 1968, came to speak on campus to students gathering in protest of the university's decision to accept government funding for a Vietnam Studies Center. Students and faculty worried that the center was an instrument of the war.

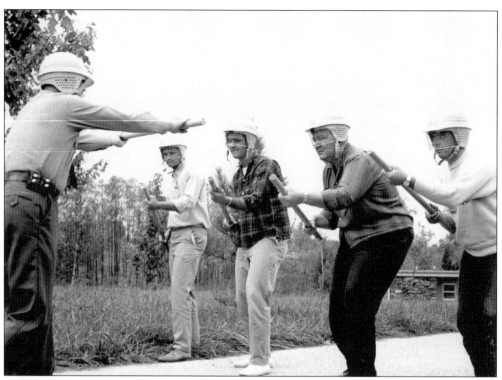

Meanwhile, university officials prepared for what might come.

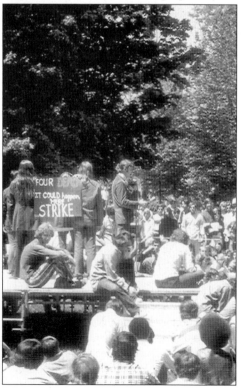

When the president ordered troops into Cambodia, student protests swept the nation. Then students on this campus and throughout the nation cringed to hear that the Ohio National Guard had killed students at Kent State and that Mississippi police killed African American students at Jackson State.

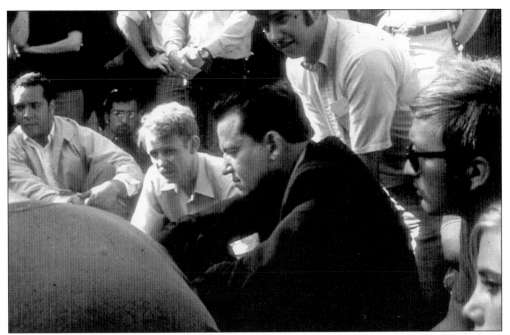

Chancellor Robert MacVicar sought desperately to gain confidence in the student body. While he called for toleration and open-mindedness for what he called "pluralist truths," students were calling for withdrawal from Southeast Asia.

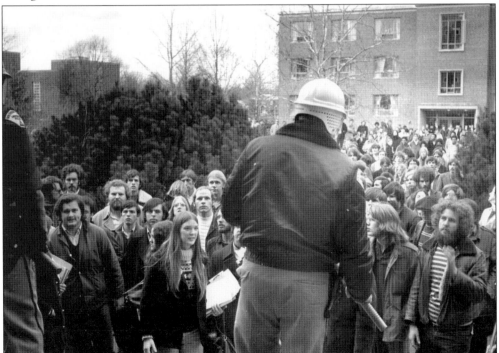

Differences of opinion turned to confrontation. The administration sought to contain the situation by suspending classes for a day. But students, like their counterparts throughout the nation, were losing patience. One target was the Vietnam Studies Center housed in Woody Hall.

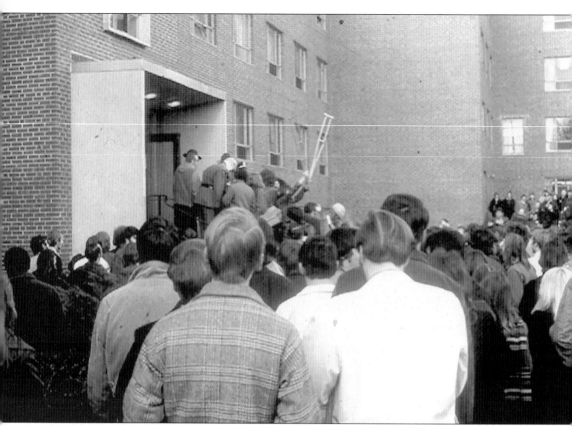

Despite assurances to the contrary, critics of the war believed that the Vietnam Studies Center was funded by the government to promote an unjust war.

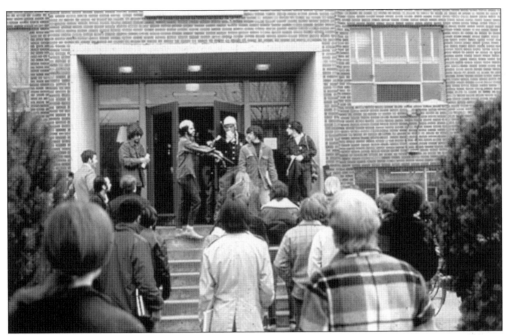

For the sake of academic integrity, students argued, the center should be removed from campus. After heated exchange on the steps of Woody Hall, students gained control of the building.

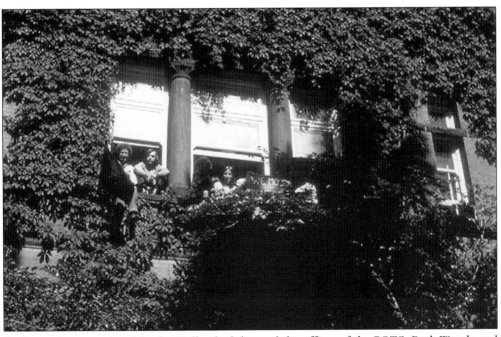

Students also turned to Wheeler Hall, which housed the offices of the ROTC. Both Woody and Wheeler Halls were occupied. Files were ransacked, and students demanded that the police be disarmed. Note the sign "We Mourn Kent."

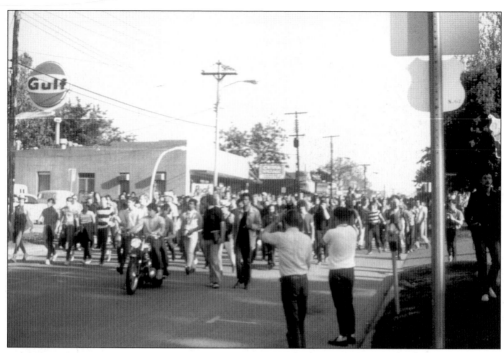

Even though authorities regained control of Woody and Wheeler Halls, the protests continued in the streets.

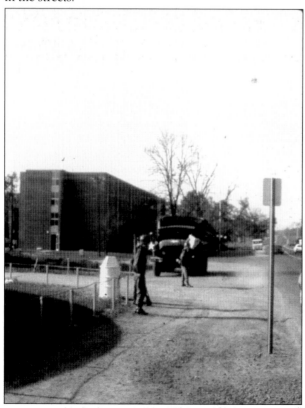

Local police were reinforced by the state police and 600 troops from the National Guard.

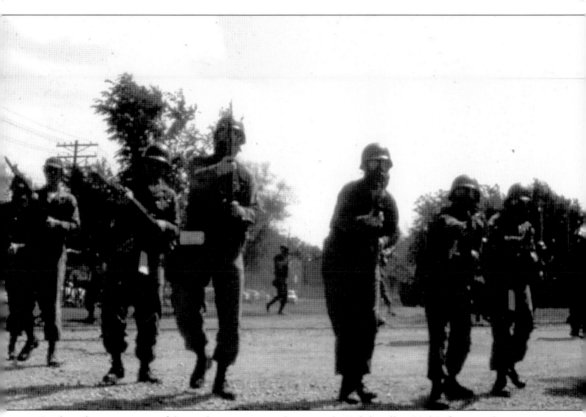

Students became aware of themselves as actors in history. Like Ralph Kylloe, Ted Orf was on the street photographing the moment. His title for this meeting with National Guard was *Time to Run*.

Outraged citizens in surrounding communities gathered to express their concern. Some talked about coming to town to teach the students an old-fashioned lesson. Ted Orf ventured to visit such a citizens meeting in Cobden to snap this picture of concerned citizens.

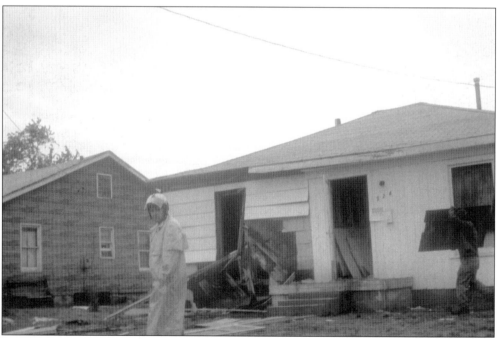

Clouds of tear gas drifted through the town and across campus. On May 12, university authorities conceded they had no choice but to shut the university down and send the students home.

70

Another story of the times involves the design department and Harold Grosowsky, fondly known as "Mr. G." His students, scattered throughout the world, remember him fondly. When stranded in the John F. Kennedy International Airport during a taxi strike, he got on the public address system asking if there was anyone who had taken his course on creative design and could give him a ride. Three appeared within minutes.

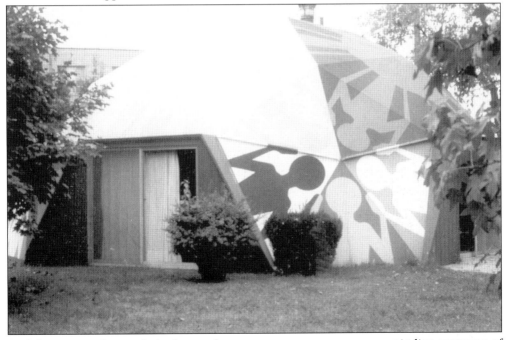

And there were the geodesic domes that sprang up across campus reminding everyone of Buckminster Fuller.

The images of turmoil and change aside, memories turn on quieter and traditional images such as these.

Four

A Long Time Ago, on a Campus Far, Far Away

Karen Mylan and Jim Whistle

How many hostages were held in Iran and for how many days? What was the Miracle on Ice? Who shot J. R. Ewing? Where were you when you heard John Lennon was assassinated?

While these issues captured the nation's attention during this decade, SIUC hosted notable figures such as Jimmy Carter, George Bush, Elvis Presley, Bruce Springsteen, Barry Manilow, and Big Bird—who briefly changed the name of Chatauqua Road to Sesame Street.

The year 1978 was a big year; on one weekend in October the SIUC and Carbondale communities enjoyed homecoming, Halloween, and a Bob Dylan concert. Some wanted to make it an annual event, but the city turned down the idea.

Tragedy struck in 1981 when student Susan Schumake was murdered. Her death led to the building of a second pedestrian bridge, the Women's Transit Authority, and brightway paths on campus. In September 2005, a man was arrested and charged with her murder.

"The Great Tissue Issue" of 1982 engulfed the campus community. After the university-supplied toilet paper was used for tree decorations, the administration cut back and allowed only two rolls per student, per semester. Outraged students complained, which resulted in local support ranging from radio-sponsored toilet paper drives to shipments that came from Paducah.

By 1977, the women's gymnastic team had won national titles 10 of the previous 13 years. Wrestling was cut under Title IX in 1982, Saluki football won the 1983 I-AA Championship, and the men's mile relay team in track and field set a record.

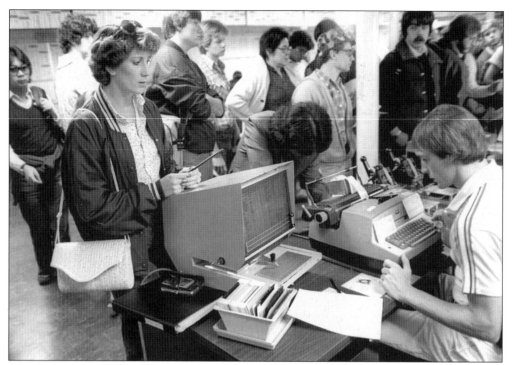

Registering for classes has never been fun, but at least in this decade students had the convenience of typewriters and microfiche. Students now can register using internet or by appointment with an advisor. (Courtesy of Media and Communication Resources, SIUC.)

The campus at SIUC is well known for its natural beauty. Thompson Woods, located in the center of campus, was off limits for a short time in 2005 when a mother deer attacked students to protect her fawn. (Courtesy of Media and Communication Resources, SIUC.)

The watermelon festival was an annual event held at the beginning of the fall semester to welcome freshmen to campus. There is no better way to meet new friends than over slices of juicy watermelon. Although it is no longer a university-sponsored annual event, occasionally the Greek system sponsors a watermelon festival as a fund-raiser. (Courtesy of Media and Communication Resources, SIUC.)

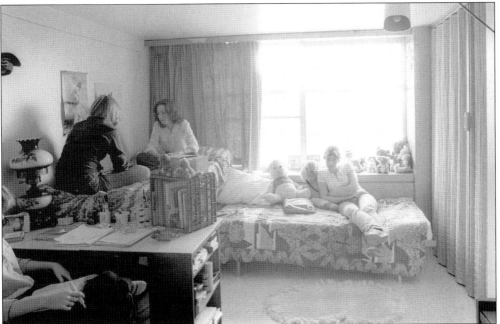

Dormitory rooms were often cramped, bathrooms had to be shared, and in this decade they were not yet smoke free. (Courtesy of Media and Communication Resources, SIUC.)

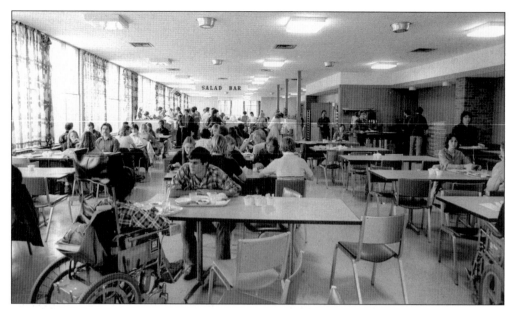

The campus cafeterias were the place to go for nourishment and company. Once students tired of cafeteria food, they could head off campus to local restaurants such as Quatros, El Greco, or the home cooked–style meals available at Mary Lou's and PK's. Now meal cards can be used at many restaurants in town. (Courtesy of Media and Communication Resources, SIUC.)

Built in the early 1970s and dedicated in April 1975, Faner Hall has always been difficult to navigate, helping to start the many rumors about its unusual layout. (Courtesy of Media and Communication Resources, SIUC.)

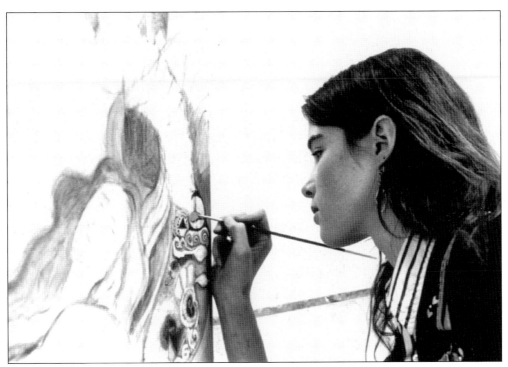

Students at SIUC during this decade could major in art and improve upon their two-dimensional skills or they could focus on computer technology and work on the most recent advances in computers. (Above, courtesy of Brad Brailsford; below, courtesy of Media and Communication Resources, SIUC.)

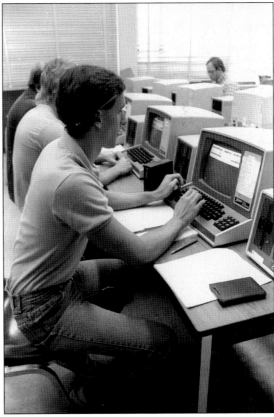

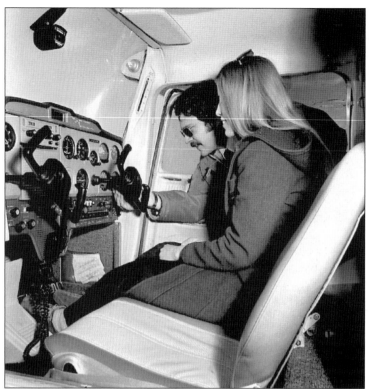

The aviation program began in the mid-1960s, but gained notoriety in the late 1970s and early 1980s, when the student group the Flying Salukis won national events. (Courtesy of Media and Communication Resources, SIUC.)

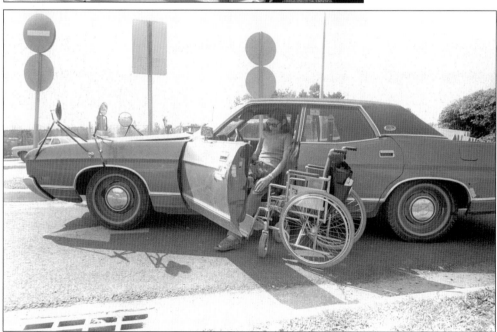

SIUC also offered specialized classes, such as the one that modified this car for a disabled student. The late 1970s saw SIUC become one of the first universities in the country to pioneer the way for disabled students by breaking curbs and pouring access ramps. (Courtesy of Media and Communication Resources, SIUC.)

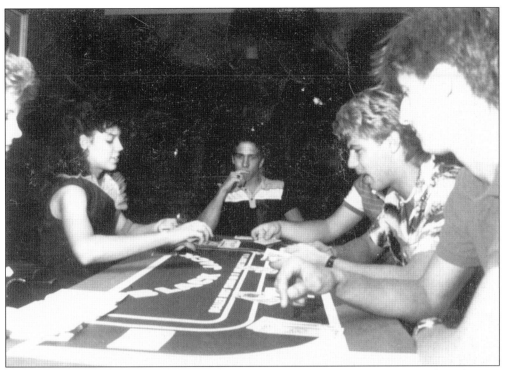

The student center and registered student organizations have sponsored events through the years to provide entertainment. Casino night was a gamble, but it was not as risky as playing the dating game. (Courtesy of Student Center, SIUC.).

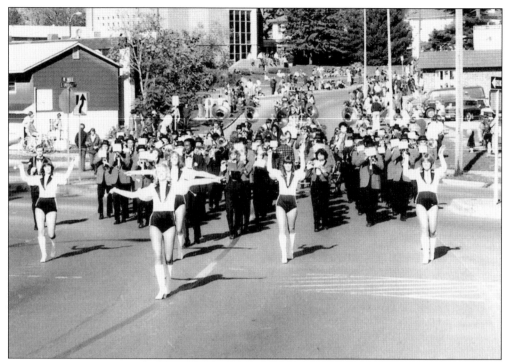

The Marching Salukis are known as the best-dressed band. In 1978, they are here with their plaid coats and bow ties. (Courtesy of Media and Communication Resources, SIUC.)

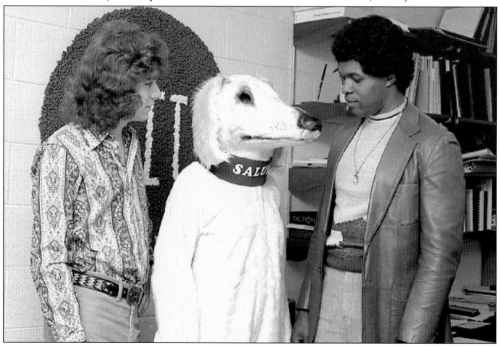

In 1978, a new Saluki mascot arrived on campus. In addition to the Saluki costume, SIUC also has had several real Saluki dogs as mascots. Tut, the first four-legged SIUC mascot, was followed by a succession of other dogs. (Courtesy of Media and Communication Resources, SIUC.)

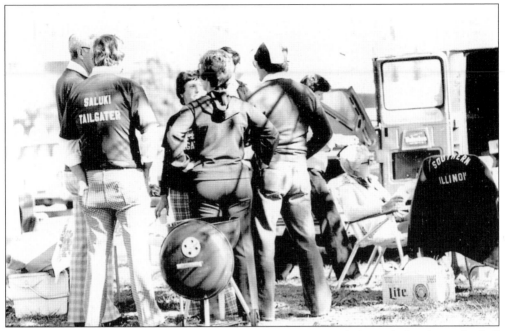

As with many universities, tailgating is a tradition for students and alumni before home football games. In recent years, students have enjoyed the experience so much, they sometimes "forget" to go to the game and support the Salukis, forcing the university in 2005 to set down strict guidelines for the parties before the football games. (Courtesy of Media and Communication Resources, SIUC.)

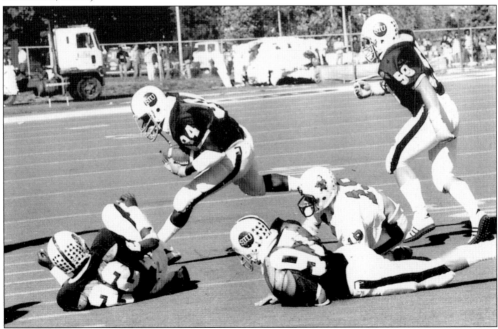

Despite this fumble recovery, SIUC lost to the Northern Illinois University Huskies 14 to 13. In 1983, the Salukis were I-AA National Champions after they defeated Western Carolina University 43-7 under Coach Rey Dempsey. (Courtesy of Media and Communication Resources, SIUC.)

Baseball fans, like football fans, turn out in large numbers for the party. The difference is that baseball fans can party on the hill during the game and never miss a home run. (Courtesy of Media and Communication Resources, SIUC.)

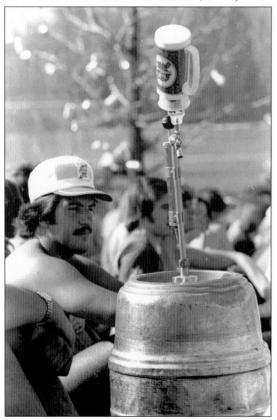

Fans came prepared for Saturday afternoon double headers by bringing a keg. (Courtesy of Media and Communication Resources, SIUC.)

Although a Saluki stole the ball away, it was not enough to stop Larry Bird and his Indiana State Sycamores on their undefeated way to the NCAA Finals in 1979. (Courtesy of Media and Communication Resources, SIUC.)

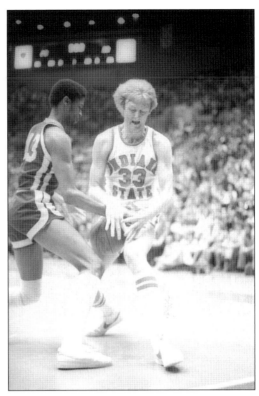

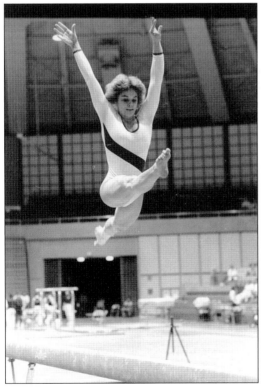

Women's gymnastics at SIUC, coached by Herbert Vogel from its inception in 1962, was once one of the best in the nation. (Courtesy of Media and Communication Resources, SIUC.)

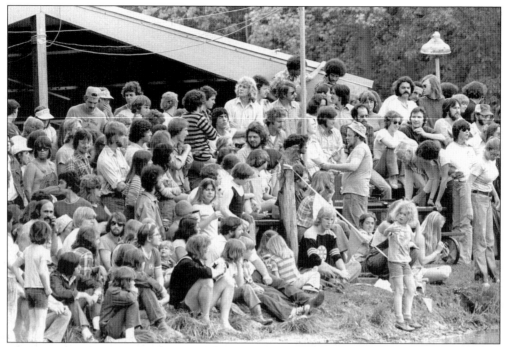

The Great Cardboard Boat Regatta started in 1974 when Richard Astor decided to come up with a fun final exam for his freshman class. Boats have to be made of cardboard only, but the design is open to participants—creativity is encouraged. (Courtesy of Media and Communication Resources, SIUC.)

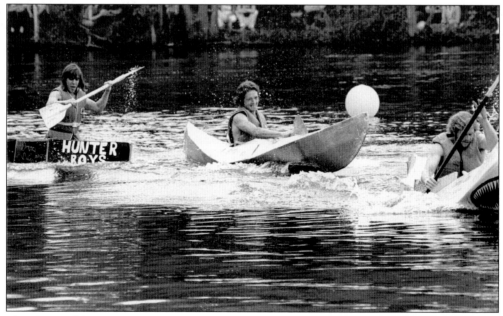

The object of the race is to win of course, but sinking can be just as exciting. Life jackets are required, and there is no alcohol allowed for safety reasons. The event is open to everyone, and three classes of boats are allowed: canoes or kayaks, experimental boats, and instant boats. (Courtesy of Media and Communication Resources, SIUC.)

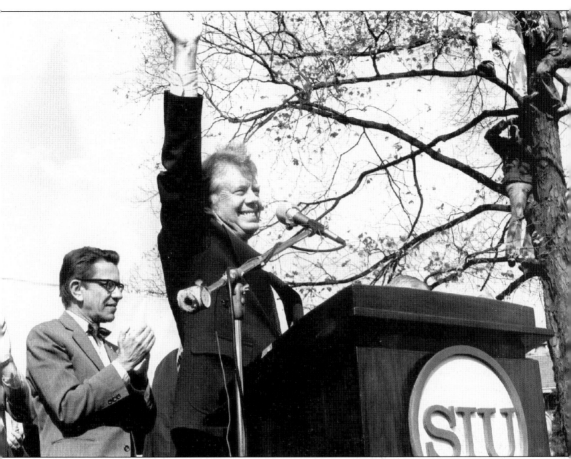

In 1976, Jimmy Carter landed in "Peanut One" in Marion and brought his campaign to SIUC. Although Carter was welcomed by Paul Simon (left) and a large crowd, his speech was ultimately cut short by hecklers. (Courtesy of Media and Communication Resources, SIUC.)

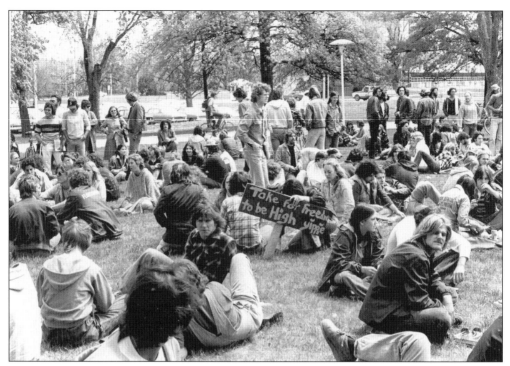

During the "Smoke In of 1978," students gathered on campus to protest marijuana laws. (Courtesy of Media and Communication Resources, SIUC.)

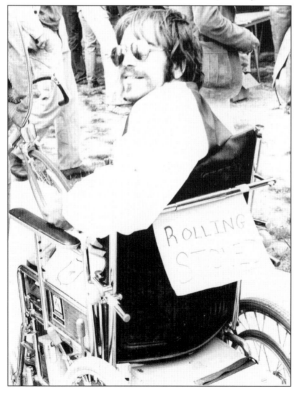

This Smoke-In of 1978 supporter arrived "rolling stoned." (Courtesy of Media and Communication Resources, SIUC.)

SIUC's Buckminster Fuller was asked to contribute his thoughts on national television during the July 1969 moon landing. Here students continue celebrating the space age in welcoming back to Earth the Skylab, or at least its debris. (Courtesy of Dave Mylan.)

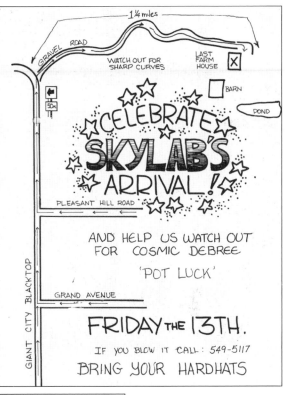

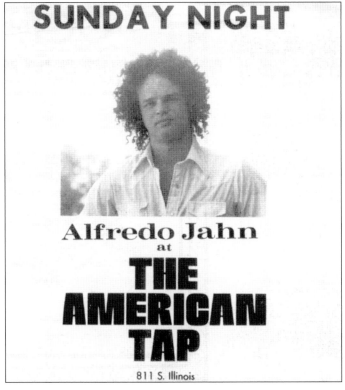

The American Tap was a favorite night spot in Carbondale for many years. Long lines of people would form down the steps and along the stone wall at night waiting to get in. The American Tap closed down and was eventually bulldozed by the city. (Courtesy of Alfredo Jahn.)

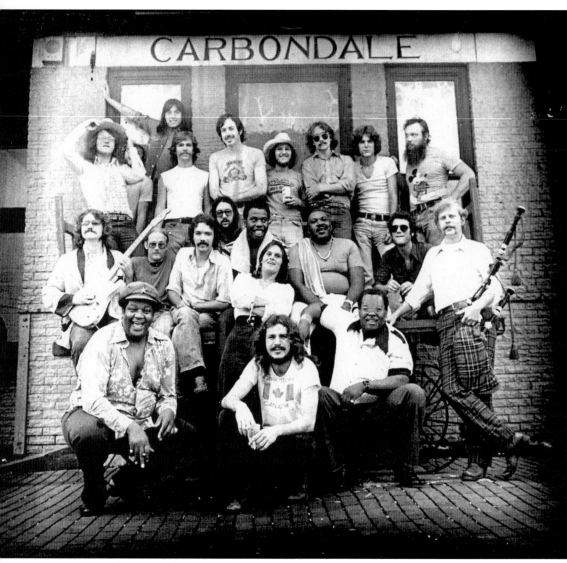

Big Twist and the Mellow Fellows along with Shawn Colvin and other local musicians stop to pose for a photograph in front of the train depot on Illinois Avenue. (Courtesy of Jay Stem.)

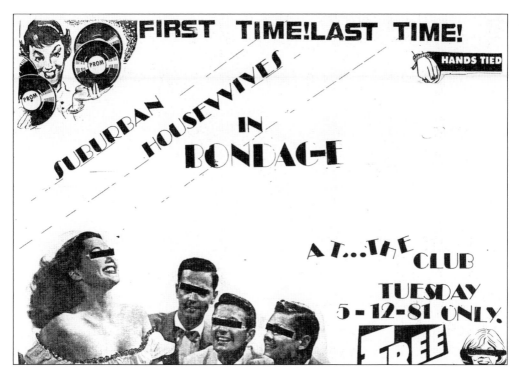

This poster has the Suburban Housewives in Bondage advertising their gig at the Club in 1981. "First Time! Last Time!" was misleading; although the Club burned around 1984, the Housewives still play gigs several times a year at PK's. (Courtesy of Dave Mylan.)

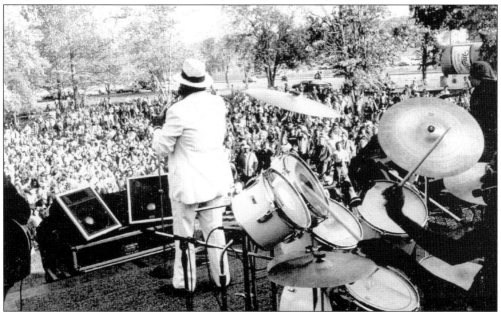

For those students who stick around Carbondale through the summer months, the Sunset Concerts are a major form of entertainment. Since 1978, the concert series has been held every summer for six weeks on Thursday nights alternating between Turley Park and the steps of Shyrock Auditorium. (Courtesy of Media and Communication Resources, SIUC.)

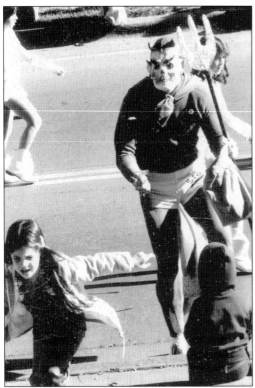

Homecoming 1978 coincided with Halloween and a Bob Dylan concert. Thousands packed McAndrew Stadium, SIUC Arena, and the streets of Carbondale to witness the event that spawned a legacy of a generation. College students and local children came together to celebrate, or in this case, run away screaming. (Courtesy of Media and Communication Resources, SIUC.)

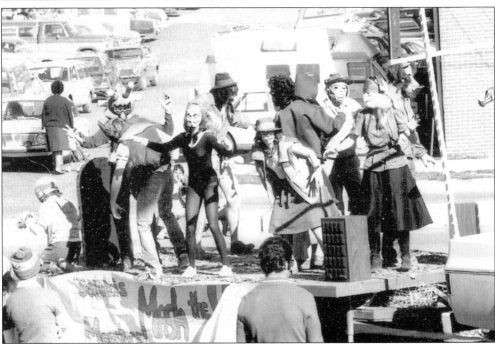

Not only did ghouls overtake the strip on Halloween night and light bonfires to keep warm, they also invaded the homecoming parade on floats. (Courtesy of Media and Communication Resources, SIUC.)

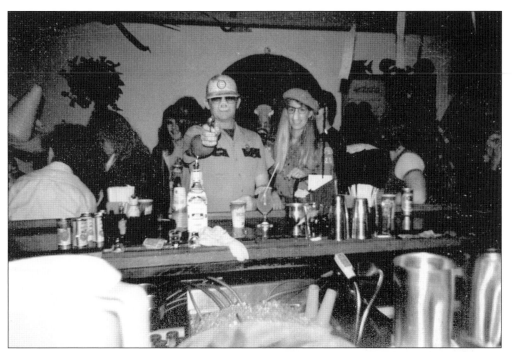

Halloween was such a spectacular success in 1978 that it was even considered for a city holiday. Although that never was made official, Halloween came to be viewed as a sort of spring break in the fall for SIUC students. (Courtesy of Jay Stem.)

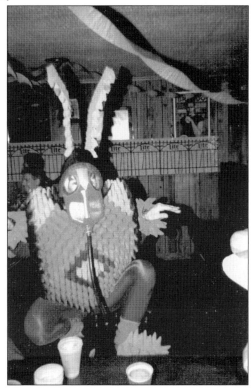

Creative costumes once dominated the Halloween party on the strip, but in the late 1980s students dressed up less and partied more. (Courtesy of Jay Stem.)

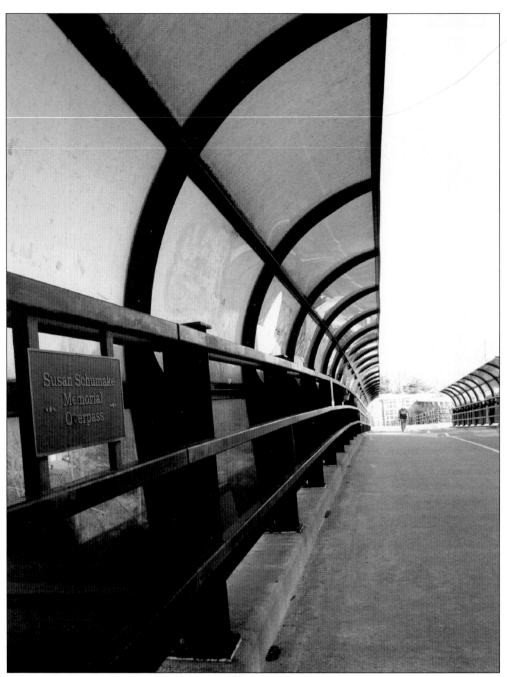

This small sign on the South Overpass on Route 51 leading from the east dorms to campus reads, "Susan Shumake Memorial Overpass." After more than two decades of searching for her killer, the Carbondale Police Department arrested and charged a man in September 2005. The March 2006 trial ended in a conviction and long-awaited closure for Susan's family and friends, as well as for SIUC and Southern Illinois.

Five

FROM ALEX KEATON TO KURT KOBAIN

David Markwell

Some images that capture the height of the Reagan era of the mid-1980s include the Challenger disaster, new wave, new Coke versus Classic Coke, Jim and Tammy Faye Baker, parachute pants, big hair, *St. Elmo's Fire*, and the Chicago Bears performing the Super Bowl Shuffle.

Gone were the days of protests and riots over American foreign policy. The mid- to late 1980s were a time of relative peace and prosperity in America and at SIUC. Michael J. Fox's character, the preppie Alex Keaton, in the television show *Family Ties* perhaps personified the student of the era.

The 1980s era of mass assembly was not wrapped around politics, but rather an ancient pagan holiday of revelry that went awry on a few different occasions—Halloween. In 1986 and again the following year, over 20,000 people gathered on the strip from cities as far as St. Louis and beyond to join in the spirited celebration. While most participants were just having harmless fun, there were over 230 arrests in 1987: it seems downtown homeowners did not appreciate their front laws being used as public lavatories. SIUC students in 2005 hear from older aunts and uncles about "the good old days" of Halloween, when drunken debauchery ruled the holiday in Carbondale.

As the 1980s gave way to the 1990s, a new era of students came to campus. They would be defined as Generation X. Not every single student can be defined by the cultural trends and shifts of any particular era, but with that limitation in mind, herein are a few snapshots from the decade of 1985 through 1994.

Captured in time is this over-the-top 1980s fashion that made its way to SIUC. Remember break dancing? Any leather pants still in the back of the closet? (Courtesy of SIUC Student Center.)

In the "low tech" days of the mid-1980s, before laptops, before iPods, and before cell phones, there was hackey sack. (Courtesy of SIUC Student Center.)

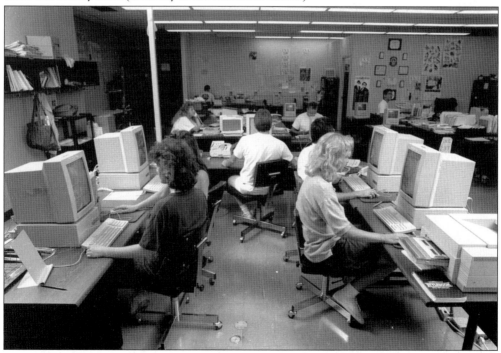

The technological revolution gained strength and prominence with each passing year of the late 1980s and early 1990s. The above shot shows students and staff in the office of the *Daily Egyptian*. Keeping up with the changing world often had students out in front of their instructors. (Courtesy of Media and Communication Resources, SIUC.)

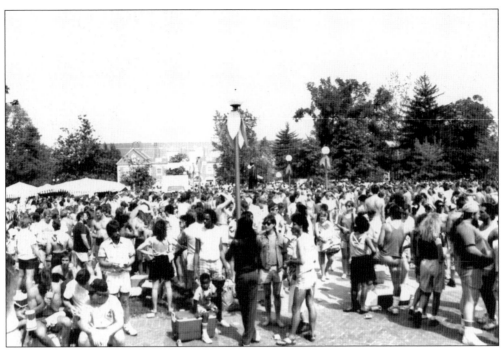

When the town quiets down between semesters, the sunset summer concerts continue to be a draw for those in Carbondale. The styles and music may have changed over the past 25 years, but the good times remain. (Courtesy of SIUC Student Center.)

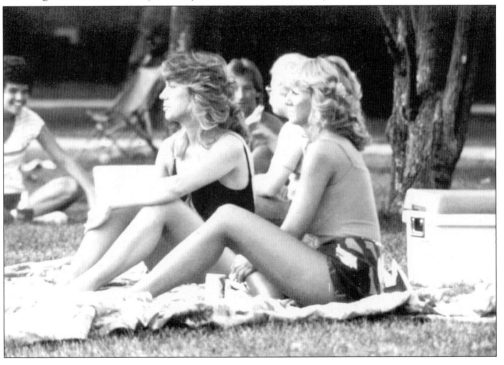

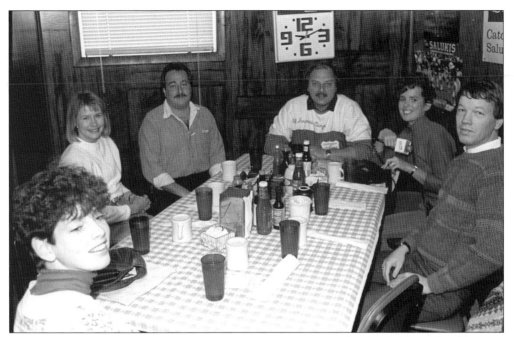

From the Carbondale strip to the Hollywood strip, *Hill Street Blues* and *NYPD Blue* television star and SIUC alumnus Dennis Franz (bachelor of arts in theater, 1968) made a triumphant homecoming and speech in Carbondale in December 1986. A meal with friends at Mary Lou's rounded out his stay. (Courtesy of Media and Communication Resources, SIUC.)

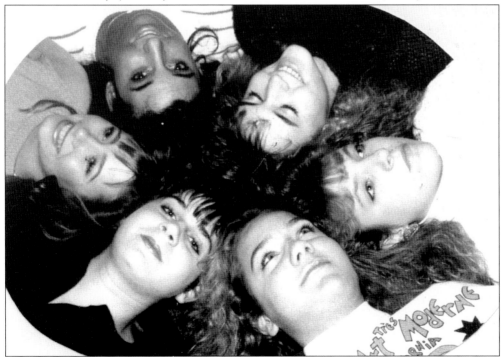

Six students, seven bottles of hair spray: they are actually stuck in this position. (Courtesy of Lucia Amorelli.)

On the political front, one of SIUC's own tossed his hat into the 1988 presidential race. Sen. Paul Simon (in a bow tie) announced his candidacy at Shryock Auditorium in May 1987. Although his campaign failed to ignite in the national polls, the elder statesman made a huge impact at SIUC and the countless students who worked on his campaign. (Courtesy of Media and Communication Resources, SIUC.)

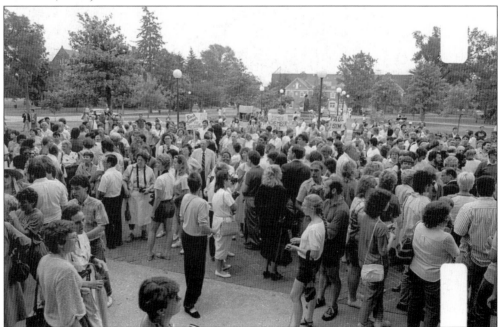

This rally outside of Shryock Auditorium followed Paul Simon's candidacy announcement. (Courtesy of Media and Communication Resources, SIUC.)

Tailgating has been a long tradition in SIUC sports history. Alumni from decades past, as well as current students, gather to cheer on the home team. Throughout the nation, on any level of sports, SIUC is the only institution to be "the Salukis." (Courtesy of Media and Communication Resources, SIUC.)

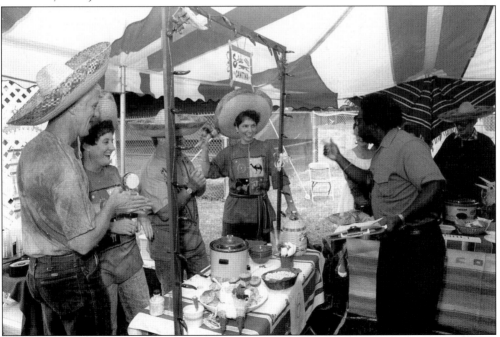

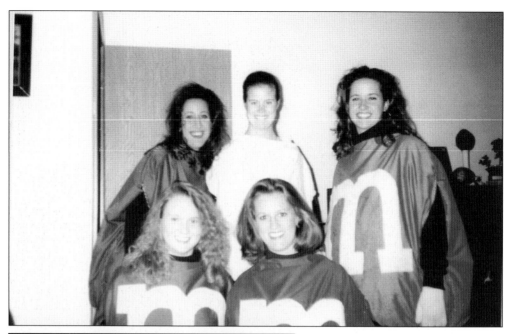

Halloween revelers prepare to
hit the strip. (Above, courtesy of
Kristine Domaracki; below, courtesy
of Karen Mylan.)

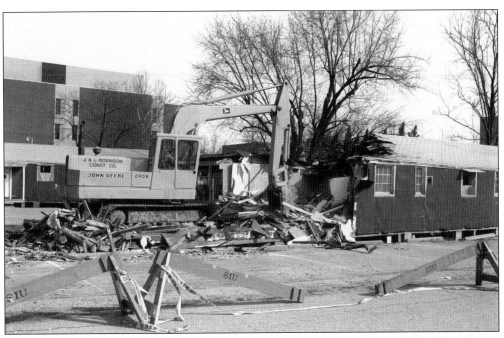

This is a shot of the main barracks being demolished in 1993. Similar post–World War II structures are few and far between. (Courtesy of Media and Communication Resources, SIUC.)

BASEMENT

Little Egypt's Fix of Rude Truth

ISSUE # 1 · APRIL 1989

THIS IS BASEMENT

THIS IS BASEMENT!

A LETTER FROM THE EDITOR...

As managing representative of staff-writers and workers, I welcome you to BASEMENT.

One thing that is perfectly clear, we at BASEMENT love America. We depend on her waters, air, and trees. Even with greedy scum-zombies puking everywhere after they've devoured a billion times their share, we are still inspired by the love we feel for our beautiful, though dam-

Short-lived underground newspapers are a staple on college campuses. Here is the inaugural edition of the *Basement* in 1989. (Courtesy of Gregory Huber.)

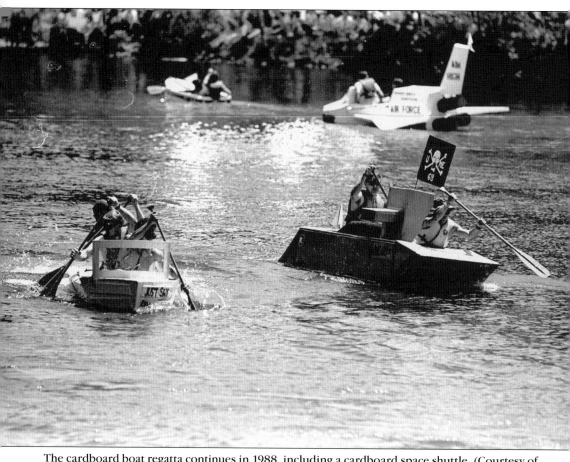

The cardboard boat regatta continues in 1988, including a cardboard space shuttle. (Courtesy of Media and Communication Resources, SIUC.)

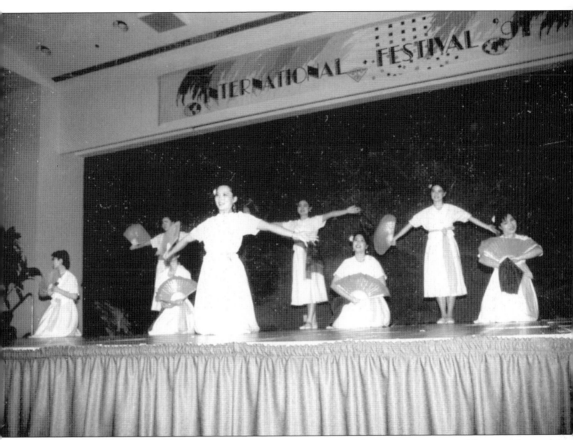

Students from all over the world attend SIUC. A celebration of cultures is captured here at the 1991 international festival. (Courtesy of SIUC Student Center.)

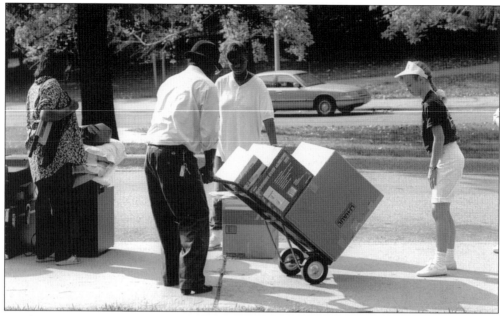

Another timeless tradition at SIUC is "moving in day" for incoming students every August. Here confident looking students and beleaguered parents cart prized possessions into Brush Tower in 1991. (Courtesy of Media and Communication Resources, SIUC.)

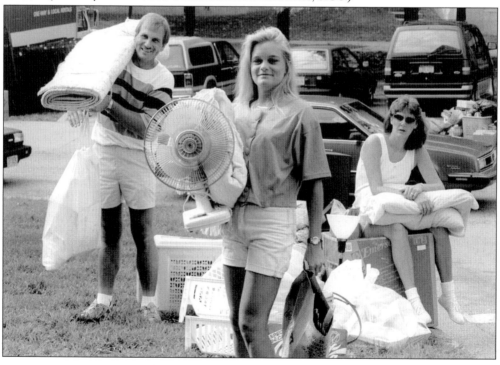

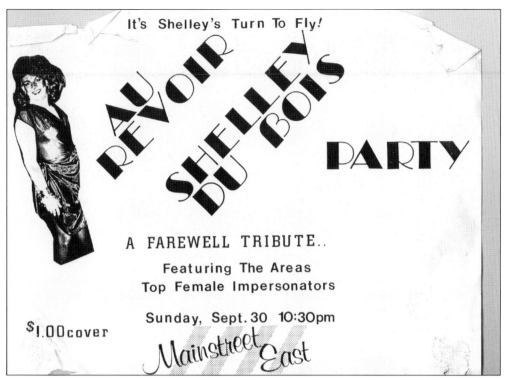

Diverse entertainment options abound at SIUC. Female impersonators appeared at Mainstreet East in the 1980s and 1990s. (Courtesy of Jay Stemm.)

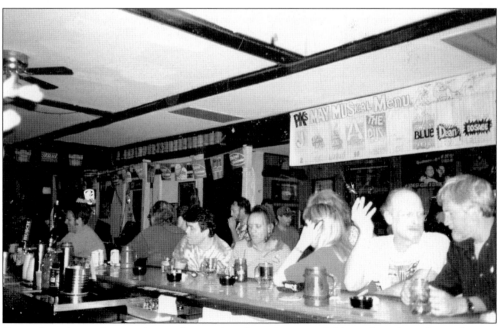

Shown here is another timeless night at PK's. Where these two "old guys" on the right professors? (Courtesy of Karen Mylan.)

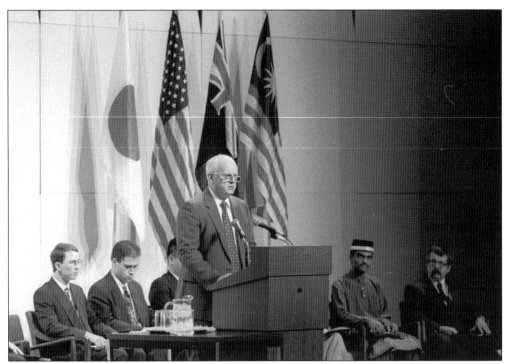

The SIUC student body experienced perhaps its darkest day on Sunday morning, December 6, 1992. A fire ignited at the Pyramid apartment complex (now Rawlings Street Apartments) on Rawlings Street. Five students from four different countries perished in the blaze. Many more were left homeless. A period of mourning was felt throughout the whole community. A memorial service was conducted at Shryock Auditorium on December 11. The four flags of the countries were on display. (Courtesy of Media and Communication Resources, SIUC.)

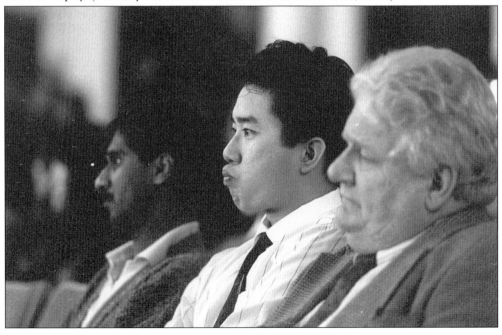

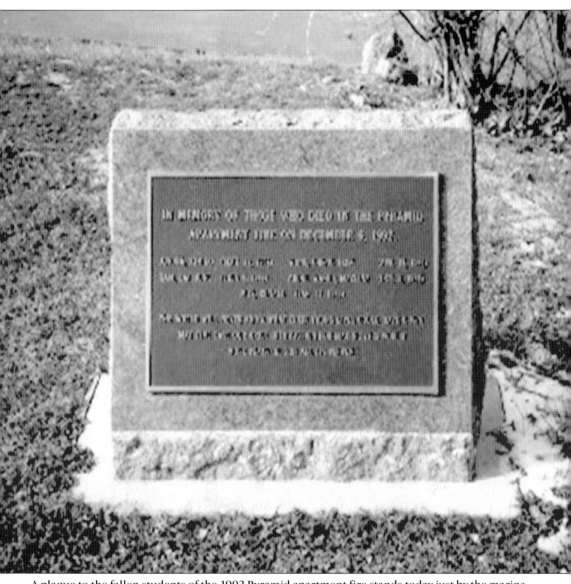

A plaque to the fallen students of the 1992 Pyramid apartment fire stands today just by the marina overlooking the campus lake. (Courtesy of Jeff Julson.)

Styles changed from the 1980s into the 1990s. Above are a group of 1980s dormitory floor friends atop Brush Tower. Below are 1992 students exhibiting the grunge look made popular by such bands as Nirvana. (Above, courtesy of Kristine Domaracki; below photograph courtesy of Media and Communication Resources, SIUC.)

Six

DO YOU PLAN TO VOTE IN THIS YEAR'S PRESIDENTIAL ELECTION?

Matthew Borowicz and Neal Young

On August 9, 1995, Jerry Garcia of the Grateful Dead died in his sleep, just two weeks before school resumed at the SIUC campus. A month later in September, Pres. Bill Clinton told crowds "I am glad to be back here at SIUC, a place which has a very warm place in my heart." By the time Clinton's second term ended, the country had entangled itself in conflicts over a stained dress and the recently bombed USS Cole in Yemen. As Y2K scared the world, Gus Bode asked students "Do you plan to vote in this year's presidential election?"

The beginning of the new millennium saw one of the closest presidential elections, and September 11, 2001, shocked the western world. Two days later, the *Daily Egyptian*'s front page read "An Act of War."

In Carbondale, thoughts and images of past Halloween riots troubled students, faculty, and locals with images of tear gas and flipped cars on the strip. Punk and "jam-grass" began to flourish, and bands like the Woodbox Gang, Broken Grass, and Coal Train played at the Hanger 9 and PK's.

The SIUC vineyards began to explode in popularity as a place for students and tourists to get away. Alto Pass, Von Jacob, and Pomona vineyards held festivals out in the hills of Southern Illinois. Former senator Paul Simon came to SIUC to start the Public Policy Institute and teach political science.

Walter Wendler became chancellor of the university and started his "Southern at 150" program. Rumblings emerged of making the sunset concerts alcohol free, and students contended with some of the greatest tuition increases in decades. Again, free speech and the student conduct code were challenged on the grounds of SIUC. Students Marc Torney and Jessica Bustos fought for student rights.

Antiwar marches and demonstrations became common sights at SIUC and in town square. The *Big Muddy Media*, an independent newspaper, drew students to help work on spreading the news, whether it was on the war in Iraq or student rights on campus. For as much as the school changed in appearance, the culture and activities that students engaged in stayed much the same as they were in the late 1960s and early 1970s. Politics and the university administration play key roles in the lives of students at SIUC.

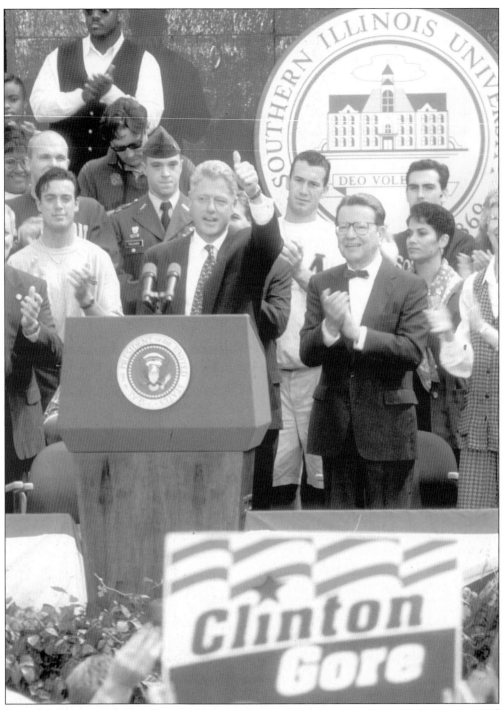

Pres. Bill Clinton, alongside Sen. Paul Simon (right), was on the campaign trail during the 1996 election (Courtesy of Media and Communication Resources, SIUC.)

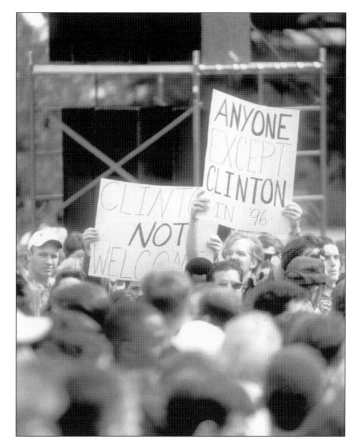

In a nod to the political diversity of SIUC, thousands gathered in September 1995 to show support for Pres. Bill Clinton as a second-term candidate, while others gathered to show just how much they wished someone (or anyone) else would win the 1996 election. (Courtesy of Media and Communication Resources, SIUC.)

Another beautiful spring afternoon in 1995 brings students out to the former free forum area just south of Anthony Hall to listen to music while doing homework or just relaxing in the sun. (Courtesy of Media and Communication Resources, SIUC.)

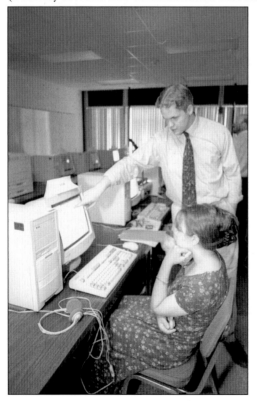

In 1995, the internet began to explode at SIUC. Many students had their fist exposure to the World Wide Web at the university, but many needed some training before that could happen. Here a student helps to explain computer use to another fellow student. (Courtesy of Media and Communication Resources, SIUC.)

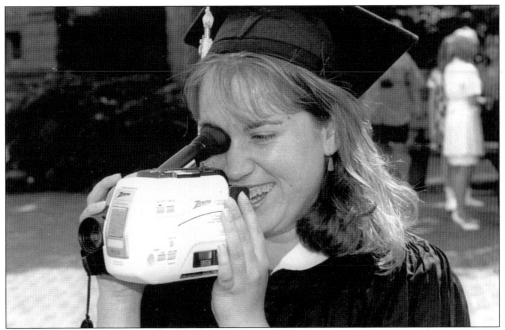

Oh, how times have changed. While the 1940s and 1950s at SIUC saw few cameras in the hands of students, the technological revolution allowed this 1995 graduate to be photographed while videotaping. Since 1995, the cell phone has infested the hands and ears of what seems to be every student passing between classes. (Courtesy of Media and Communication Resources, SIUC.)

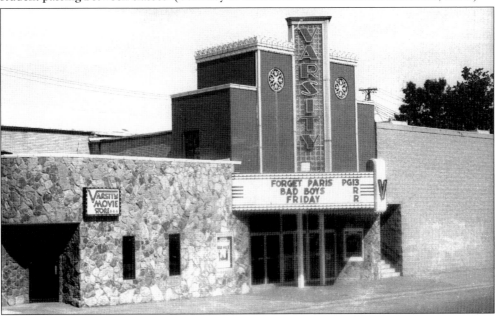

The Varsity Theatre, well known in Carbondale for more than 60 years, saw its last movie played, as Kerasotes Theatre chain bought and boarded up the historic building in June 2003 on the heels of the new multiplex built at the University Mall. Carbondale citizens stepped forward in a campaign to "Save the Varsity," but as of yet, the building remains closed. (Courtesy of Media and Communication Resources, SIUC.)

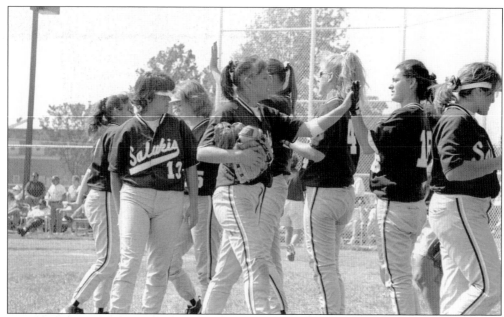

The 1995 Saluki softball team congratulates each other after a game. Behind them is the vestige of a less than equal field on which they played. Thanks to a 2000 title IX complaint filed against the university, a protest staged by parents of the 1999 team, and a $1.5 million proposal approved by the board of trustees, the softball team now plays at the 2003 completed Charlotte Webb Stadium across from the recreation center. (Courtesy of Media and Communication Resources, SIUC.)

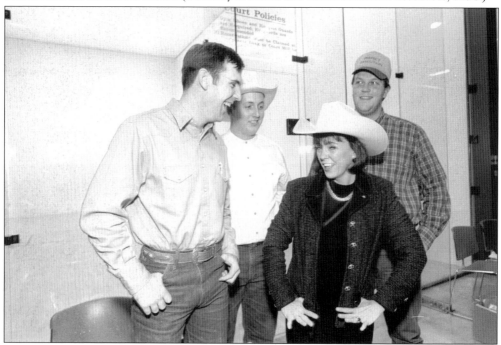

History professor and former chancellor Jo Ann Argersinger shows off her cowgirl moves at a 1999 RSO (Registered Student Organization) event in the SIUC recreation center. (Courtesy of Media and Communication Resources, SIUC.)

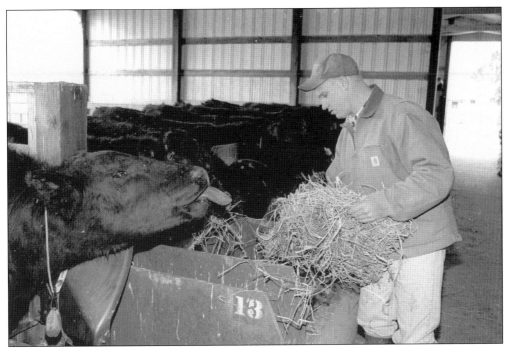

One of hundreds of cows attending SIUC in 1999 bellies up to the bar as a college of agriculture student serves up another round. SIUC is home to acres of farmland and livestock shelters. (Courtesy of Media and Communication Resources, SIUC.)

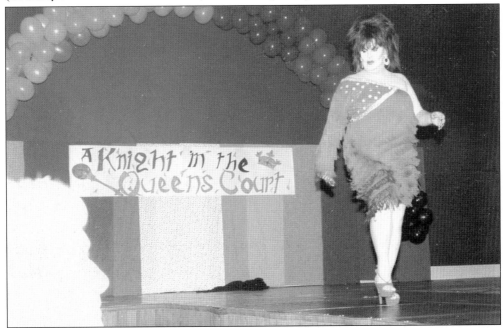

Blanche DuBois, a local drag-queen favorite, is on the catwalk at the annual drag show in 2001. The event is sponsored by the SIUC Saluki Rainbow Network and held in the student center, drawing a crowd of hundreds each year. The show features men and women dancing and lip-synching as a way to celebrate the diversity SIUC has long represented. (Courtesy of SIUC Student Center.)

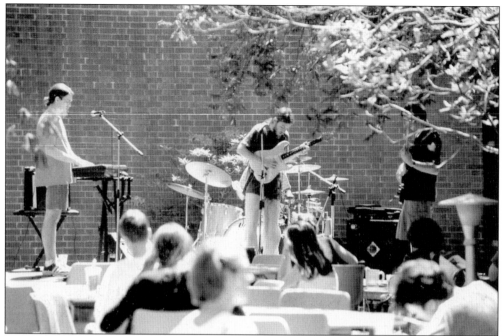

Caravan, a local jazz ensemble, plays the 2001 "Noon Tunes." The events give students a taste of local bands on the back patio of the student center, where they can relax for a few minutes between classes. (Courtesy of SIUC Student Center.)

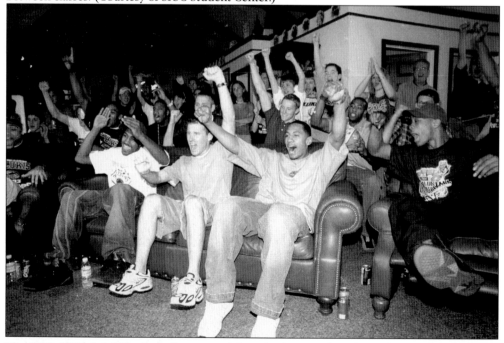

The 2002–2003 Saluki basketball team and friends cheer at the televised news that SIUC has received its second consecutive at-large bid for the NCAA tournament. Although defeated in the first round of the "Sweet 16," the often struggling SIUC athletics program had finally carved out a place in national sports news. (Courtesy of Media and Communication Resources, SIUC.)

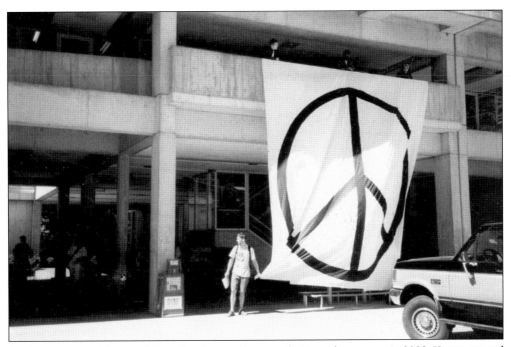

Student peace activists participate in a banner drop on the Faner breezeway in 2003. Unannounced (and unauthorized) events like this were often utilized in making a statement on the wars in Iraq and Afghanistan. (Courtesy of Interfaith Center, Carbondale, Illinois.)

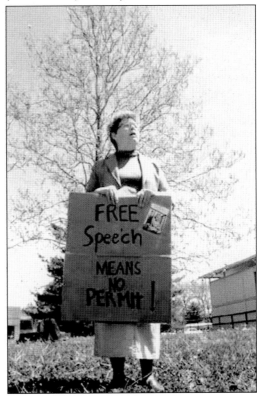

Just as students marched alongside nearly striking faculty during the contract negotiations of 2002–2003, faculty stood alongside students when freedom of speech was challenged by the university administration in 2004. Students and faculty challenged the university's rule that said anyone wishing to speak freely outside of the 30-by-30-foot grassy knoll between Faner Hall and the student center must ask and receive permission from the administration or risk sanctions through judicial affairs. (Courtesy of Big Muddy Media, Carbondale, Illinois.)

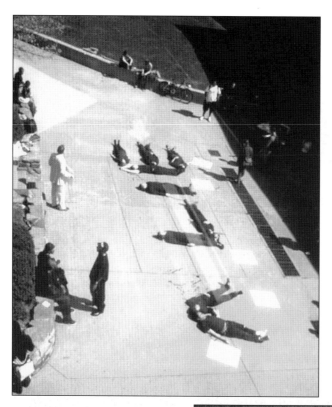

A "die-in" was staged between the student center and Faner Hall in 2003. Students here make a graphic display of the death caused by their perception of the Bush administration's weapons of mass destruction claim by spelling out "A LIE" in blood-covered bodies. (Courtesy of Big Muddy Media, Carbondale, Illinois.)

Police question students at the "die-in" outside the student center. Students covered themselves in fake blood and lay silent to represent dead soldiers fallen to spell out "A LIE." Student Marc Torney was charged with violating the student conduct code for not having a permit for this event. Torney, who was handing out antiwar fliers near the silent event, claimed to be separate from the die-in when approached by police. (Courtesy of Big Muddy Media, Carbondale, Illinois.)

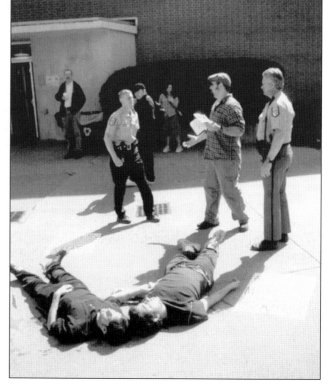

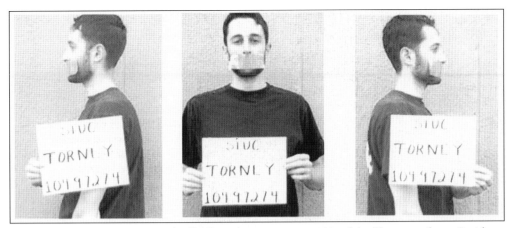

The free speech issue, and specifically the right to protest outside of the "free speech area" without a permit, was challenged on campus by such groups as the Big Muddy Independent Media Center. This photograph was broadcast in the newspaper and on posters around campus to demonstrate what happens when people exercise their first amendment rights at SIUC. (Courtesy of Big Muddy Media, Carbondale, Illinois.)

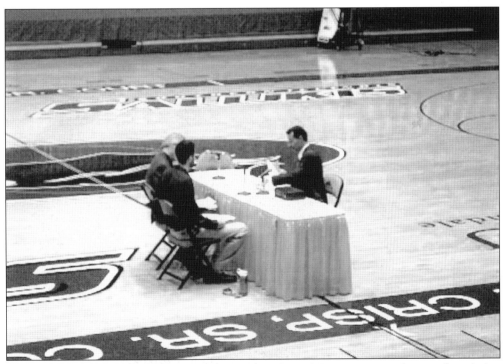

A strict ban on cameras did not prohibit this photograph of the Marc Torney hearing from being taken in 2004. This case, charging Torney with protesting without a permit, drew so much attention and outcry that the proceedings were moved from a small office in Woody Hall to the SIUC Arena. (Courtesy of Big Muddy Media, Carbondale, Illinois.)

Join us and take a stand for justice
at the trial of Jessica Bustos,
Wednesday, the 8th, @ 8pm
Woody Hall, B-145

SIU brings student to trial, based
on incident that happend off-campus
while she was not enrolled. City
charges were dropped but SIU insists
on jeapordizing rights to education.

If the free speech trial of Marc Torney seemed at first unjust, the Jessica Bustos trial made it look like a rational and legitimate case. During the trial of Jessica Bustos, a non-student who was arrested for an alleged fight (charges were later dismissed by the city) in an off-campus incident, serious questions were being raised even at the administrative level about the scope of the student conduct code. The question of the day, from the Big Muddy Independent Media Center to the undergraduate student government, was just how far the university was willing, able, and capable of going to police its student population (and evidently non-student population). This poster was yet another propaganda piece used by the Big Muddy Independent Media Center to win support among the Carbondale population and bring attention to the perceived abuse of power by SIUC judicial affairs. (Courtesy of Big Muddy Media, Carbondale, Illinois.)

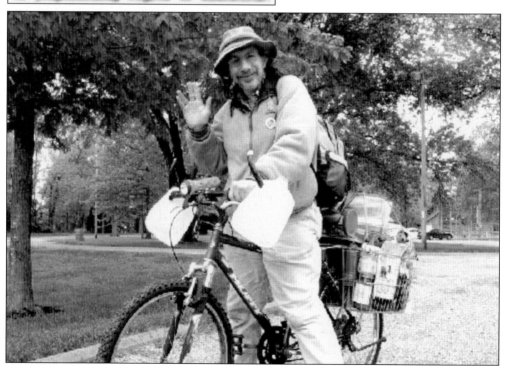

Shown here is Lloyd Rich, also known as "Time Lloyd." (Courtesy of Big Muddy Media, Carbondale, Illinois.)

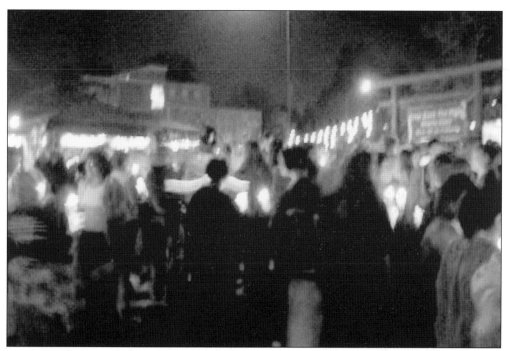

A crowd gathers at the interfaith center as the Take Back the Night march, organized by the women's center, ends. The event helps raise awareness of domestic violence and draws a crowd of hundreds each year. (Courtesy of Big Muddy Media, Carbondale, Illinois.)

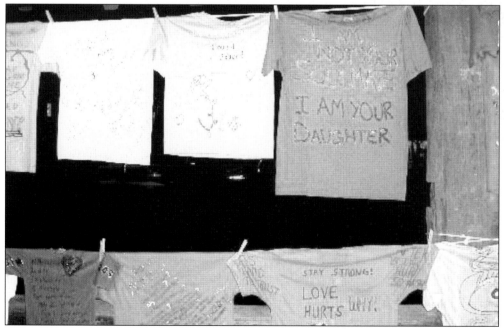

These are T-shirts hang in the town square pavilion for the Clothesline Project. Each shirt represents the struggle that sexual violence brings to those who are forced to deal with its aftermath. Every year hundreds hang in Faner breezeway and in the town square. (Courtesy of Big Muddy Media, Carbondale, Illinois.)

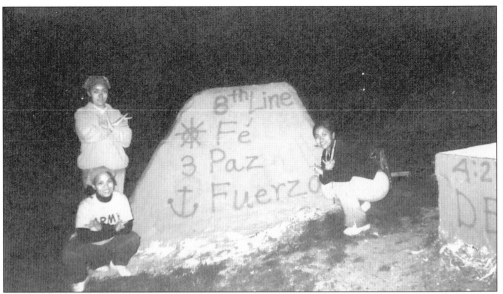

Dubbed the "pride rocks," these large stones (originally the base of a water tower) sat east of the student recreation center for more than three decades, offering themselves since 1987 to students expressing their unity, their joy, and sometimes their hatred. Here members of the Sigma Lambda Gamma sorority show off their sisterhood on a cold spring night in 2002. The pride rocks, after 18 years and up to three quarters of an inch of paint, were demolished in early 2005 to make room for a new student housing project. (Courtesy of Yesenia Espinoza.)

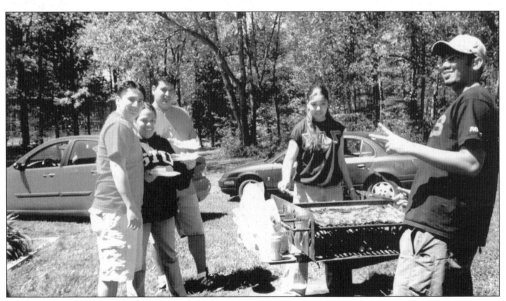

Sigma Lambda Gamma sorority and Sigma Lambda Beta fraternity enjoy an end-of-the-year barbecue at Buckey's Haven. With Campus Lake, Thompson Woods, and many picnic and recreation areas, SIUC offers something many other universities' students never experience: outdoor fun and relaxation on campus. (Courtesy of Yesenia Espinoza.)

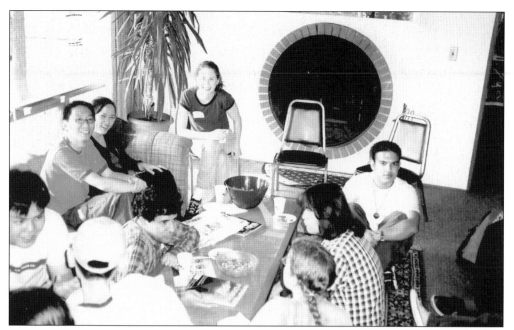

SIUC students from all over the world converge at the interfaith center in 2003 for International Coffee Hour. This popular event has been drawing dozens of students every Friday, for many of the 60 years the interfaith center has operated, as a way to celebrate the international, spiritual, and religious diversity of the campus and community. (Courtesy of Interfaith Center, Carbondale, Illinois.)

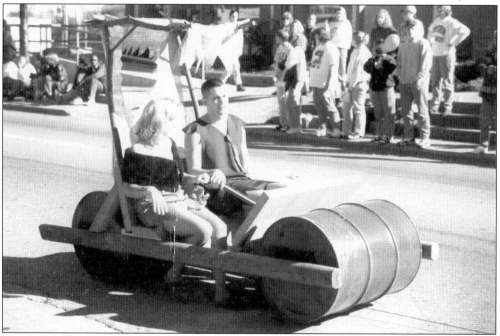

The cardboard boat regatta and the homecoming parade have long been a way for students to show off their creativity and take part in the school and community. These two are a pair of modern Stone Age students peddling their way down Illinois Avenue in 2001 as Fred and Wilma. (Courtesy of Interfaith Center, Carbondale, Illinois.)

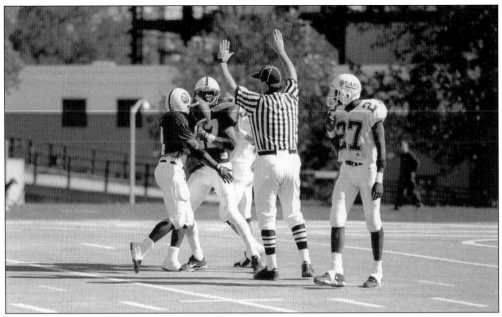

The Saluki football team played the Southeast Missouri Bears during homecoming in 1995. The game was close, and the Salukis came away with a 33-30 win in overtime. (Courtesy of Media and Communication Resources, SIUC.)

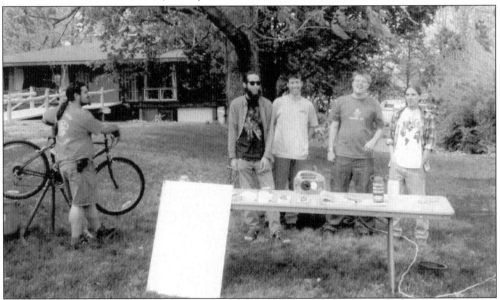

Aur Beck (far left) offers free bike repairs and tune-ups at the corner of Illinois and Grand Avenues as part of the 2001 Earth Day celebration. Members of the Student Environmental Center, a registered student organization for more than 20 years at SIUC, stand ready to discuss issues of environmental importance with people who stop by. SIUC is well known for its progressive environmental actions, including a large solar power system, vermicomposting (using worms) of food waste, alternative fuel vehicles in their fleet, a community bicycle use program, a state-of-the-art recycling program, and a myriad of other environmentally friendly programs. (Courtesy of Interfaith Center, Carbondale, Illinois.)

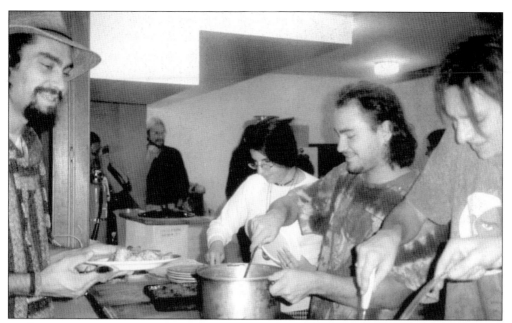

Students and community alike line up for the annual Thanksgiving dinner at the interfaith center. Members of the Student Environmental Center usually take the lead in preparing the mostly vegan meal that feeds many hundreds of people in just a few hours. The interfaith center event is well known for sharing healthy, home-cooked food with the community as a way to bring people together in peace, faith, and celebration. (Courtesy of Interfaith Center, Carbondale, Illinois.)

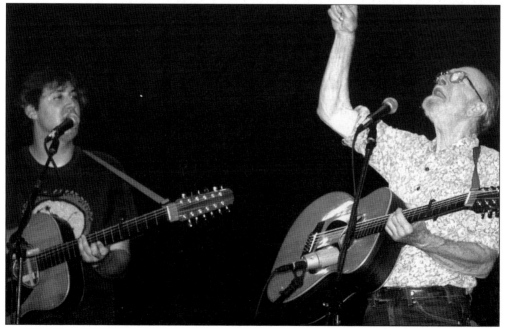

Folk singer, political and labor activist, and accused communist of McCarthy-era fame, Pete Seeger leads the audience at Shryock Auditorium in a sing-along. With his grandson Tao Rodriguez, left, Seeger performed his timeless music to a full house of everyone from babies to their grandparents in September 2001. (Courtesy of Media and Communication Resources, SIUC.)

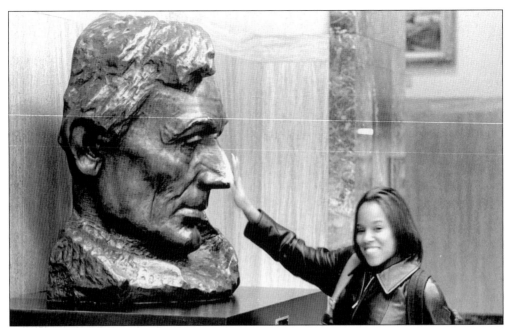

An SIUC student looks to Abe for luck on her exams. This particular statue sits in the main hall of Morris Library. After decades of use, Morris Library will finally receive a major overhaul, costing more than $30 million and spanning enough years for the average undergraduate currently enrolled to not see its completion. The fate of this well-used good-luck charm is unknown. (Courtesy of Media and Communication Resources, SIUC.)

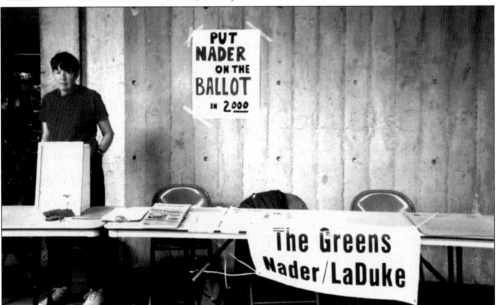

The Campus Shawnee Greens conduct a petition drive for the placement of presidential candidate Ralph Nader on the Illinois voting ballot. Jackson County, considered by many the bastion of liberalism in Southern Illinois, gave Nader the highest percentage of votes in all Illinois counties at almost 5.5 percent. Carbondale represented much of that, showing Nader support to the tune of 22 percent. (Courtesy of Interfaith Center, Carbondale, Illinois.)